thing
New Sculpture from Los Angeles

Hammer Museum
Fellows of Contemporary Art
Los Angeles

This publication accompanies the exhibition
Thing: New Sculpture from Los Angeles, organized by
James Elaine, Aimee Chang, and Christopher Miles
and presented at the Hammer Museum,
February 6–June 5, 2005.

The exhibition is sponsored by the Fellows of
Contemporary Art. Additional support is provided
by the Murray and Ruth Gribin Foundation and
The Fifth Floor Foundation.

The Armand Hammer Museum of Art and Cultural
Center is operated by the University of California,
Los Angeles. Occidental Petroleum Corporation
has partially endowed the Museum and constructed
the Occidental Petroleum Cultural Center Building,
which houses the Museum.

Published by the Armand Hammer Museum of Art
and Cultural Center
10899 Wilshire Boulevard
Los Angeles, California 90024-4201
www.hammer.ucla.edu
and the Fellows of Contemporary Art
777 South Figueroa Street, 44th floor
Los Angeles, California 90017
www.focala.org

ISBN: 0-943739-28-4

Copy editor: Karen Jacobson
Designers: Michael Worthington & Megan McGinley
Principal photographer: Joshua White
Printed by Typecraft, Inc., Pasadena, California

Contents

Director's Foreword

Thing: New Sculpture from Los Angeles is the third in an ongoing
series of large-scale exhibitions at the Hammer Museum
highlighting the work of emerging artists. Of these, two—
Snapshot and *Thing*—have focused exclusively on artists from
our own active and exhilarating region.

In 2001 I, along with the other curators of *Snapshot*, wrote,
"we are convinced that more exciting new work is being made
here than in any other city in the world." Now, in 2005, that
persistent conviction, along with our observation of a resurgence
of interest in object making in the past few years—has led to this
exhibition. *Thing* turns its attention to this phenomenon, focusing
on current sculptural practice in Los Angeles.

I wish to extend my appreciation to Claudine Isé, former assistant
curator at the Hammer Museum and current associate curator of
exhibitions at the Wexner Center for the Arts, for first suggesting
the idea. I am deeply grateful to the Fellows of Contemporary
Art for their enthusiastic support for this exhibition and for their
unflagging dedication to the art and artists of the region. Thanks
are due in particular to Rubin Turner, chair of the board of
directors; Donna Vaccarino, exhibition liaison; and Mary Leigh
Cherry, administrative director.

My sincerest gratitude also goes to the Murray and Ruth Gribin
Foundation and The Fifth Floor Foundation. Without their
generosity, the exhibition would not have been possible.

Thanks are also due to the curators of the exhibition: James
Elaine, for his tireless pursuit of the most noteworthy new art,
both for the Hammer Projects and for this series of exhibitions;
Aimee Chang, for her dedication to emerging artists and her
enthusiasm for the project; and, finally, to Christopher Miles,
whose familiarity with the Los Angeles art scene led us to some
unexpected places and whose insight is reflected in the catalog
essay. This exhibition represents the first time we have invited an
independent curator to collaborate with our in-house curators.
Chris's expertise and considerable contributions made this a
wonderful and enriching experience.

Finally, I wish to express my utmost respect and deep appreciation
to the artists in the exhibition. Their work is, in the end, why it
all matters.

Ann Philbin
Director
Hammer Museum

Sponsor's Foreword

In recent years Los Angeles has become a breeding ground for innovative art, with many of the city's artists attracting both national and international recognition. Integral to that cultivation has been the Hammer Museum. The exhibition program at the Hammer has been vigorous and exploratory, supporting established and emerging artists from all over the world working in a wide range of media. The museum's exhibition program has helped to make Los Angeles a delineating influence in international contemporary art.

The Fellows of Contemporary Art is an independent nonprofit organization dedicated to sponsoring exhibitions that promote both emerging and midcareer California artists. It is with great enthusiasm that, in honor of its thirtieth anniversary, the Fellows is acting as the lead sponsor of *Thing: New Sculpture from Los Angeles*, an exhibition of work by twenty Los Angeles–based emerging artists who represent a wide range of sculptural practices.

Thing is the Fellows' thirty-seventh exhibition since 1975 and marks our second collaboration with the Hammer Museum. The highly acclaimed *Scene of the Crime* in 1997 featured work by thirty-nine California artists who have explored a "forensic" aesthetic. Our mandate to support California artists through exhibitions and illustrated scholarly publications is a vision that is shared by all our members. This is an exciting opportunity to celebrate and experience compelling new trends in sculpture from Los Angeles.

On behalf of the Fellows of Contemporary Art, I would like to thank Ann Philbin and the board of directors of the Hammer Museum for their continued vital pursuit of current dialogues in art. We would like to thank the exceptional team of curators—led by James Elaine, with the assistance of Aimee Chang and Christopher Miles—for taking on the monumental task of meeting with artists and selecting work for this exhibition. We are also grateful to the museum's director of development, Jennifer Wells, who has been instrumental in the administration of the project.

Exhibitions would not happen without the generous support of the membership of the Fellows of Contemporary Art and our Long-Range Planning Committee. We express our gratitude to the 2004 committee chair, Cathie Partridge, and to the exhibition liaison, Donna Vaccarino, for their diligence in coordinating the activities of the Hammer Museum and the Fellows; to Russ Kully

for his legal eye; to our administrative director, Mary Leigh Cherry, and our intern, Natalie Schorr, for their dedication, perseverance, and constant optimism.

Most important, our sincere appreciation is extended to all the artists who have contributed to this exhibition. Their work, vision, and exploration of contemporary issues create a provocative image of how "things" are.

Rubin Turner
2005/2006 Chair, Board of Directors
Fellows of Contemporary Art

Acknowledgments

This exhibition is the result of the dedication and assistance of a large number of people, to whom we are deeply grateful. The support of our sponsors made it possible to realize an exhibition and catalog of this ambitious scope, and we thank the Fellows of Contemporary Art, the Murray and Ruth Gribin Foundation, and The Fifth Floor Foundation for their generosity and for sharing our vision. Also crucial to the success of this project was the willingness of the lenders to the exhibition to part with works from their personal collections. We are grateful to Matt Aberle, J. Ben Bourgeois, Martin and Rebecca Eisenberg, Jeffrey Kerns, Shirley Morales and Kevin McSpadden, Gerald V. Niederwieser, Merry Norris, Peter Norton, Antonio Puleo, Paul Rickert, Craig Robins, Paul Rusconi, Laura Steinberg and B. Nadal-Ginard, and Dean Valentine and Amy Adelson.

Thanks are also due to the many individuals and galleries who were unstinting with their assistance: Altoids Curiously Strong Collection; Lisa Tamiris Becker of the CU Art Museum, University of Colorado at Boulder; Jessica Bronson; David Bunn; Mary Leigh Cherry of cherrydelosreyes, Los Angeles; James Corcoran; Genevieve Devitt of Griffin Contemporary, Santa Monica; Roy Dowell; Sam Durant; Christopher Erck of Finesilver Gallery, San Antonio; Patricia Faure and Kim Light of Faure & Light Gallery, Santa Monica; Rosamund Felsen of Rosamund Felsen Gallery, Santa Monica; James Goodnight; Doug Harvey; Anna Helwing and Calvin Phelps of Anna Helwing Gallery, Los Angeles; Parker Jones of the Black Dragon Society, Los Angeles; Niels Kantor; Anton Kern and Michael Clifton of Anton Kern Gallery, New York; Kunsthaus Graz, Graz, Austria; Marcia Goldenfeld Maiten and Barry David Maiten; Daniel J. Martinez; David McAuliffe and Nowell Karten of Angles Gallery, Santa Monica; Mobberly-Springmeier Collection; John O'Brien; Michael and Crystal Paselk; Andrea Rosen, Laura Mackall, and Laurel Jensen of Andrea Rosen Gallery, New York; Gaby and Wilhelm Schuermann; Kelly Taxter and Pascal Spengemann of Taxter & Spengemann, New York; Richard Telles and Deborah Hedes of Richard Telles Fine Art, Los Angeles; Dean Valentine; and Susanne Vielmetter and Gosia Wojas of Susanne Vielmetter Los Angeles Projects.

This publication was designed by Michael Worthington. His willingness to collaborate and his creative eye are both much appreciated. Our editor, Karen Jacobson, was generous with her time and energy in shaping the texts. Photographer Joshua White and his assistant, Tom Villa, were also a crucial part of the publication: their many beautiful images enliven the book. Thanks are also due to curatorial intern Matthew Thompson for his thoughtful contributions to the catalog.

At the Hammer Museum, Director Ann Philbin has been a dedicated supporter of the exhibition and an ongoing source of inspiration. Chief Curator Russell Ferguson has been generous with his assistance, insight, and considerable expertise. Our thanks also go to Jennifer Wells, director of development, and her staff—Karen Weber, Stacen Berg, and Andrew Kaiser—who helped secure essential funding for the exhibition. Our registrars, Portland McCormick and Julie Dickover, shepherded the works from disparate locations to the Hammer and back again, and Mitch Browning and Steven Putz installed the works in our galleries. Our new director of administration, Stacia Payne, dedicated her organizational energies to the project. In addition, Cassandra Coblentz, head of academic initiatives, and James Bewley, head of public programs, spearheaded the public programs for the exhibition. Steffen Böddeker, along with Melissa Goldberg and graphic designer Sean Deyoe, coordinated all the press, publicity, and design for the exhibition with the assistance of Cynthia Wornham. Thanks are also due to administrative assistant Sophia Rochmes; she joined our staff and the project in October and has skillfully managed myriad details, large and small, since. Each member of the museum's staff played a part in this undertaking, and we also wish to thank George Barker, Lynn Blaikie, Ken Booker, Cynthia Burlingham, Paul Butler and his staff, Jennifer Cox, Claudine Dixon, Andrea Gomez, Bette Jo Howlett, Mo McGee, Grace Murakami, Michael Nauyok and his staff, Catherine O'Brien, Dave Paley, Paulette Parker, Rebecca Perez, Carolyn Peter, David Rodes, Trinidad Ruiz, Roberto Salazar, Maggie Sarkissian and her staff, Mary Ann Sears and Deborah Snyder.

Finally, we wish to thank all the artists who contributed work to the exhibition. Their creativity, generosity, and dedication are at the heart of this project.

James Elaine
Aimee Chang
Christopher Miles

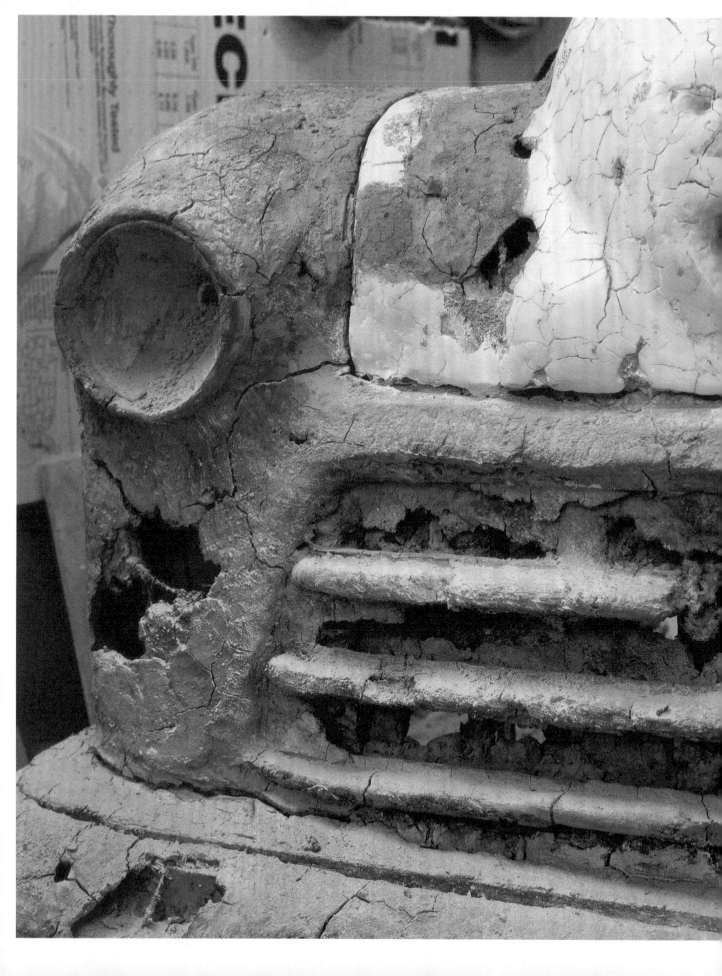

A Thing for Things

CHRISTOPHER MILES

What else might one call the odd bunch of objects in this exhibition of new sculpture from Los Angeles, which includes the likes of Hannah Greely's doormat bearing a 3D ghost image of a dog lying on it; Lara Schnitger's freestanding, self-actualizing clothing and costumes; Lauren Bon's photograph-embedded monoliths; Kate Costello's oddly referential head and body forms; Rodney McMillian's found decorator paneling; Kaz Oshiro's painstakingly replicated kitchen cabinets and amplifiers; Krysten Cunningham's structures built of joined "God's eyes"; and Taft Green's elaborate interpretive model of the Port of Los Angeles?

Thing seems the perfect title for a gathering of such unexpected objects, as the category of things is so broad that the word thing is used as a kind of universal noun for referring to anything we can't categorize more specifically. In the Marvel comic Fantastic Four, when Ben Grimm was transformed into a stone-skinned humanoid monster, he was given his name by a character who proclaimed, "Ben's turned into some kind of a Thing!" The 1951 Christian Nyby sci-fi/horror film The Thing and John Carpenter's 1982 remake by the same title tell the story of an alien monster that steals the identities of others while its own nature remains elusive. When Volkswagen introduced a strange-looking car in the 1970s, it was christened the Thing. And the disembodied hand that performed household duties on the 1960s television show The Addams Family was affectionately dubbed Thing. We use the word thing in such a manner, suggesting that the strange and unfamiliar something we behold is, if nothing else, a thing, because, technically speaking, everything is a thing or, to put it another way, the category of things includes anything and everything.

As a title for an exhibition of sculpture, Thing may seem less than clarifying. In the hazy climate of contemporary sculpture, however, to speak or write of things is to imply the difficulty of grappling with sculpture as a category of art and is in fact to make a distinction and to narrow the field. Sculpture, as it has come to be understood as a term, is highly elastic. Although it once referred specifically to that which is sculpted—and generally suggested objects in the round, tableaux, or discrete elements in relief—it now includes virtually anything designated as art that deals in three dimensions. Even the readymades of Marcel Duchamp—common objects plucked from the world around us that rejected the sculptedness of sculpture—have been enveloped within the category. The work from the 1960s based in geometric forms that Robert Morris preferred to call "objects" or "present-day three-dimensional work" and Donald Judd called "specific objects"—both of them attempting to define minimalist objects as outside the category of what previously had been understood as sculpture[1]—are now also regarded essentially as falling within the category. And over the last few decades sculptors have explored, it would seem, virtually every imaginable approach to structure, form, and

space. Writing in 1979, Rosalind Krauss, in her essay "Sculpture in the Expanded Field," commented: "Nothing, it would seem, could possibly give to such a motley of effort the right to lay claim to whatever one might mean by the category of sculpture. Unless, that is, the category can be made to become almost infinitely malleable."[2] Krauss argued that the category of sculpture constituted only a peripheral portion of a field of artistic exploration of form and space so broad as to include experiments in architecture and earth art. Yet the category of sculpture has proved itself malleable indeed, encompassing virtually everything in Krauss's field, including architecture, environments, space, people, action, and phenomena.

So while sculpture has about it a kind of anythingness, assimilating practices well beyond the scope presented in this exhibition, what we generally speak of as things constitutes a focused, object-centered selection of the totality of things. The choice of *Thing* as a title for this exhibition thus relates directly to our interests going into this project: to broadly explore the anythingness of sculpture while focusing on sculpture within the limits of objecthood. This focus does not represent a reactionary gesture—an attempt to roll back the expanded field of sculpture into some narrower, tidier version of itself. This exhibition is, however, responsive to what in some instances might be a reactionary impulse and more likely is a broadly shared drive toward specialization or focused investigation on the part of many emerging artists in Los Angeles: a reinvestment in objects. Such a drive toward the object has been evident in countless gallery exhibitions in Los Angeles over the last few years, and in museum exhibitions such as *Mise en Scène: New L.A. Sculpture*, cocurated by Bruce Hainley and Carole Ann Klonarides at the Santa Monica Museum of Art in 2000. It is seen too in this exhibition, which does not represent the full range of sculptural practice but does sample from a rich vein, and which includes work by artists whose practices are devoted largely, if not primarily or totally, to the production of sculptural objects.

Such reinvestment in the production of objects suggests at least a partial move away from assorted performative and environmental/architectural/installational approaches to sculpture and also a reassertion of objects, often with an emphasis on the handmade and the custom, in a primary role as art rather than as secondary elements in more conceptually based practices. Witness Kristen Morgin's life-size piano and car formed by hand of clay and cement; Aragna Ker's pieced-together constructions; Joel Morrison's sleek yet clumsy quasiabstract forms; Renee Lotenero's amalgamations of tile and domestic furnishings; and Michael O'Malley's carefully fabricated networks of wood, steel, plastic, and plaster elements. In her essay "The Redemption of Practice," a landmark notation of the return to taking sensual and intellectual pleasure in art objects during the 1990s, Libby Lumpkin wrote: "Artists are making things again. And the things they are making come in styles and colors and shapes and sizes that matter."[3] And the artists in the present exhibition are doing so too, with a vengeance. These are artists who have a thing for things.

The objects in this exhibition are quite far from what often was meant when the word *object* was last central to the discourse of sculpture, just prior to the expansion of sculpture into the broad field that Krauss described and also prior to what Lucy Lippard termed the "dematerialization of the art object"[4] in the late 1960s and early 1970s. At that time the object seemed to take on a secondary or supporting role as prop, tool, byproduct, or evidence in the proliferation of practices—including performance, process art, and conceptual art—that would define much of postminimalism. For Krauss, sculpture, at that moment when objects were still central to it, was exemplified by the geometric forms of Robert Morris,[5] who defined such objects as "a first step away from illusionism, allusion and metaphor," as well as "obviously removed from and separate from the anthropomorphic."[6]

Far from Morris's notion of the object, the works in this exhibition suggest an embrace of the overtly representational and referential in sculpture. Consider Jedediah Caesar's detritus sealed in resin; Matt Johnson's hyperreal representations of natural and man-made forms; Andy Ouchi's commingled references to art and nature; Mindy Shapero's storybookish objects, their attributes exaggerated

and mixed up; Olga Koumoundouros's iconic log cabin; Nathan Mabry's fascination with references to kitsch and to folk, ancient, and modern culture; and Chuck Moffit's investigation of the signification of the automobile. The works in this exhibition reveal a preoccupation with making objects unabashedly intended to allude, represent, suggest, and signify. They also reveal a preoccupation with various familiar objects in the world around us that also allude, represent, suggest, and signify. Hence, one might say that this is an exhibition of objects about objects or things about things, as objecthood seems to double. Though certainly interested in exploring and addressing humanity, the artists in this exhibition are getting at humanity through its things—pictured, referenced, simulated, and embedded in new sculptural works.

Describing pop art's essential connection to duplication, repetition, and reference, Andy Warhol once said, "It's liking things,"[7] and it becomes clear upon examining the work in this exhibition that much of it owes a debt to pop. But the creative forebears and relatives of the artists represented in this exhibition range broadly, spanning the globe and the last century. What they share is an interest in the formal and connotative possibilities of art objects and familiar objects of all kinds. Precedents for the work in Thing include Meret Oppenheim's fur-lined teacup; David Hammons's stacked liquor bottles and homemade basketball hoops; Matthew Barney's fetishized motorcycles and gym equipment; Jasper Johns's bronze beer cans; Cady Noland's urban castoffs; Wim Delvoye's ornament-lavished everyday machines; Allan McCollum's "surrogates" for common things; Sherrie Levine's gilded duplicates of Marcel Duchamp's found urinal; Claes Oldenburg and Coosje van Bruggen's monuments to objects we find in our pockets and cabinets; Gabriel Orozco's manipulations and alterations of found objects ranging from a skull to a car; and Jeff Koons's recontextualized, recast, and remade utilitarian and decorator objects.

Precedents and kin to the works in this exhibition are also found closer to home, in recent sculpture by Los Angeles artists. Works by Robert Therrien and Jennifer Pastor provide precedents for the manner in which several artists in Thing reference familiar objects through approximate resemblance of shapes, attributes, or qualities. Caesar's sliced orb of junk embalmed in colored resin and encased in concrete and plaster recalls sliced-open geodes or solidified amber encasing fossils. A work by Moffit is suggestive of a tiny comet or a gigantic sperm crossbred with a car. Schnitger's structured fabric works are kin to costumes, just as Cunningham's works in yarn and string and wood and metal are direct descendents of decorative objects and furniture. Shapero meanwhile mixes and matches attributes of familiar objects and phenomena to quasimagical ends (rocks with feathers or scales, clouds with legs). Costello's cement and cellulose forms hover on the edge of representation or referentiality, seeming in the end to refer generally to types of sculpture.

Like Los Angeles–based predecessors Charles Ray, Adrian Saxe, Liz Craft, and Roland Reiss, many of the artists in this exhibition—with varying degrees of realism, surrealism, and even hyperrealism—make objects that carefully mimic (in some cases painstakingly duplicate) objects familiar to us. Witness Greely's dog/mat and handcrafted Budweiser bottles, McMillian's simultaneously limp and rigid balloon, Johnson's bronze of a jigsaw puzzle standing freely on edge, Morgin's piano and lowrider, Oshiro's exacting stand-ins, and Ouchi's simulated snow-covered crag and stylized plastic plant life. Mabry forms and casts ceramic simulations and derivations of cartoonish plastic bones. Bon directly embeds photographic negative transparencies of found objects in newly fabricated objects, jumbling two and three dimensions, positive and negative, original and copy.

Ed and Nancy Reddin Kienholz, George Herms, Betye Saar, Nancy Rubins, Chris Burden, Mike Kelley, Martin Kersels, Rubén Ortiz-Torres, Jason Meadows, and Jason Rhoades are just a few in a long line of Los Angeles artists who, like more than a few artists in Thing, have developed practices around lifting objects directly from their world and incorporating, embedding, and assimilating them into the production of sculpture. Caesar's orb is a kind of time capsule of studio refuse; the slick skins of Morrison's forms both hide and reveal the shape of their junk-crammed insides; and Moffit's

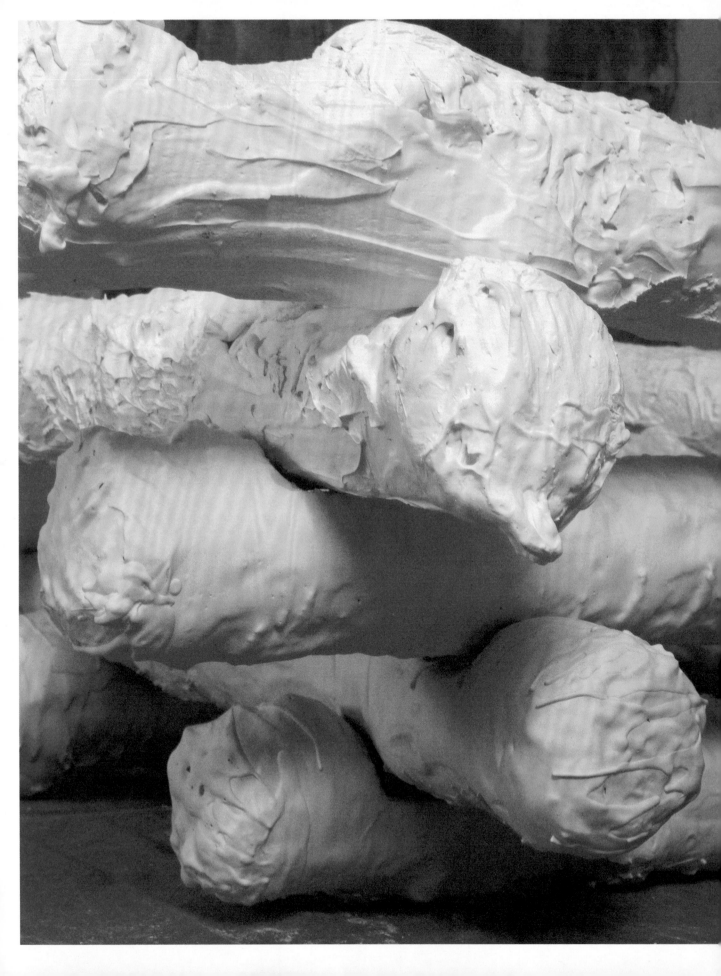

abstracted fantasy of speed and power revolves around the banal mass of a Ford 302 engine. O'Malley chops up a found hollow-core door and converts the resultant modules of contained space into the building blocks of quasi-architecture. McMillian's paneling, straight from the deinstallation of someone's office or den, begs a reconsideration of its Duchampian gesture, flaunting its foundness but also asserting its power as a collection of evocative objects. Lotenero hand-makes many of the ceramic elements in her works but mixes them up with items straight from the hardware or thrift store.

In addition to displaying a broad range of approaches to utilizing and referencing familiar objects, the works included in Thing also reveal a range of investigation and play regarding the status, role, and potential of sculptural objects. The relationship between sculptural objects and architecture, for instance, comes up again and again. In the long wake of sculpture practices aspiring to the scale and spatial concerns of architecture and amid a cultural climate in which the aspirations and priorities of architecture seem at times to be leaning toward occupying the status of sculptural objects (a trend well known to Los Angeles) and in which architectural models have become stand-ins for art objects as architecture gains favored status in art museum exhibitions, it is curious to see several artists compressing architecture and architectural space within sculptural objects. Lotenero, whose contained objects are suggestive of exploded architectural spaces, reverses the expansion from sculpture to installation and delivers something more like an installation in an object. Ker shifts scale and toys with equivalencies and the idea of container as object in marrying within one form the structures of a church, a pew, and a coffin. Koumoundouros reduces the idea of a log cabin to a kind of absurdly iconic form. Green and O'Malley translate the architectural language of scripted space and infrastructural flow into the sculptural language of concavity and convexity, linear and planar form, and penetrated mass. Cunningham converts what we might call purposeless decorative objects into building technologies and units for the construction of objects that suggest architecture but ultimately assert their status as sculpture. McMillian's panels present the sort of standardized building units one might expect to find in a

minimalist practice à la Carl Andre, but they have been fitted to architectural space, and now removed from that context/use and returned to a classic minimalist presentation, they still bear the traces of their functional employment.

Figurative sculpture simultaneously seems very absent and very present in this exhibition, as several artists adopt strategies used by the likes of Ray, Craft, and Pentti Monkkonen, in which objects become surrogates or stand-ins for the figure: see Morgin's car and piano carcasses; Johnson's orange-peel elephant; Morrison's klutzy amalgamations, suggestive of bags of guts; Schnitger's costumes; Mabry's statues and bones; and Costello's busts. Other artists in the exhibition use the object as a site for noting phantoms or absences: Bon's two-dimensional figurines, McMillian's displaced paneling, Oshiro's lonely cabinets, Greely's conjuring mat, and Ouchi's shadow-imprinted steps.

Artists represented in this exhibition also explore the possibility of fusing objecthood with illusionism. Johnson's bronze jigsaw puzzle directly mimics and amplifies the fusion of illusion and materiality found in its referent, pitting the presence and implied endurance of bronze against the illusory photographic "capture" of a fleeting sunset. Bon, who embeds photographic images within three-dimensional forms, and Ouchi, who uses a sculpture as a means of storing and displaying mounted photographs, also play on the materiality of the fleeting image, begging questions about the status of the material object as support/frame for the image. Ouchi pushes this idea further, producing steps marked with a silhouette that mimics the way that shadows track across forms or, more specifically, the way that the atomic blast at Hiroshima etched shadows into concrete. Lotenero, who incorporates found images into her constructions and also photographs her works as she constructs and reconfigures them, sometimes incorporating her photos back into the evolving work, makes image a building block of object. Green creates elaborate three-dimensional constructions, the elements of which, when viewed from certain angles, line up in actual space to generate spatial illusions according to principles of perspective commonly utilized in two-dimensional representations.

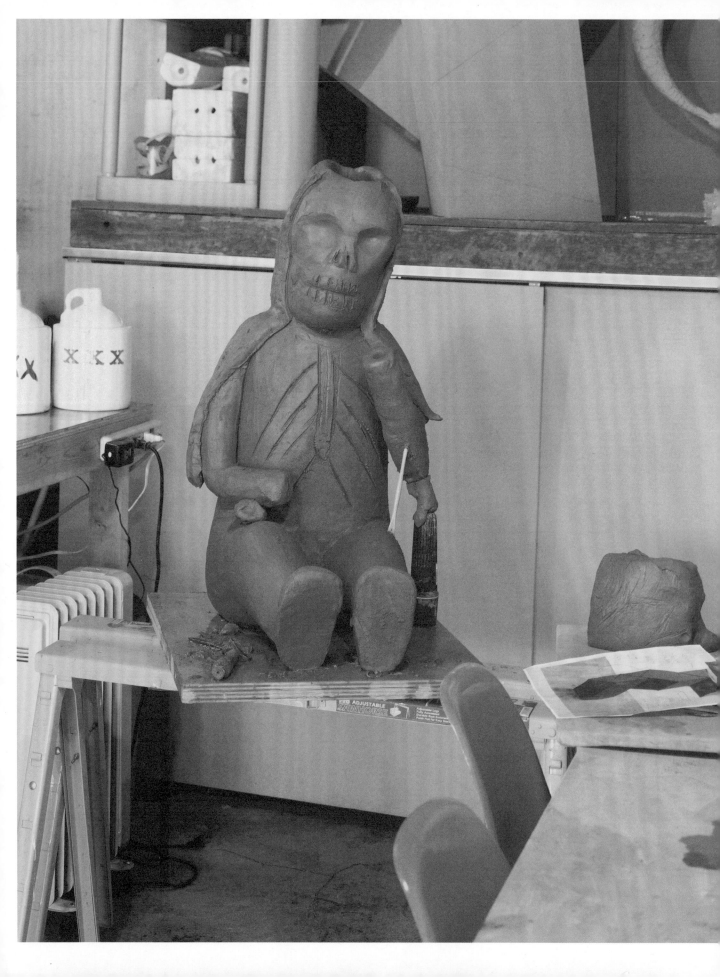

As have many of their local predecessors—the Kienholzes, Saar, Herms, Burden, Reiss, Kelley, Saxe, Jorge Pardo, Rachel Lachowicz, Jud Fine, and Barbara McCarren among others—the artists represented in Thing find a range of opportunities for referencing and using familiar objects, whether found or replicated, as tools for probing political and social content, for begging philosophical questions, and for bridging and blurring class and cultural boundaries. Caesar and Morrison literally pack modernism with trash. Mabry mixes high and low, so-called primitive and so-called modern. Bon inserts Eastern into Western. Cunningham mixes up art, craft, and decor. Koumoundouros's cabin conflates the frontiers of modernism and westward expansion.

In many cases, the things in this exhibition, in addition to and perhaps over and above all other concerns, seem to grapple with and negotiate their relationships to the sculptural objects and artists' practices that have come before them. Costello attempts to work between tendencies toward the figurative and the minimal. As Morrison takes on Constantin Brancusi and Henry Moore, Johnson nods to Alberto Giacometti and Richard Serra. McMillian crosses Duchamp and Hammons with John McCracken. Koumoundouros's cabin funks up Tony Smith, and Mabry uses forms resembling works by Smith and Sol LeWitt as Brancusian bases for primitivesque figures. Ouchi's works suggest a sliding scale of reverence and irreverence for the likes of Anthony Caro, Bas Jan Ader, and Bruce Nauman. Bon, Oshiro, and Caesar deny the minimalist object its nonreferential position by filling or covering it with content. Ker injects the late-modern, rigid, masculine austerity of a minimalist floor piece with the folk/feminine/decorative attributes of a quilt. Also visible in the works included in Thing is the ongoing consideration of sculptural languages and sensibilities ingrained in the Los Angeles scene; one sees, mixed and matched as well as blurred, the legacies of funk, light and space, finish fetish, pop, and hyperrealism.

As already noted, the artists represented in this exhibition find kin among artists reaching back through the twentieth century and spanning out across geographical space. That Los Angeles,

which has become a thriving center of art production in an increasingly internationalized art circuit, should play host to artists preoccupied with objects perhaps comes as little surprise, but what stands out about the Los Angeles art scene at the moment is the proliferation and variation of such reinvestment in sculptural objects. It seems only right that such practice should blossom in a city utterly full of things that point to or pretend to be something else, a place where artists have ready access to both inspiration for and the means and materials of endless object production. And this regional blossoming also seems to make sense in an area that, as it blossomed as an art scene, gave us object-oriented artists like the Kienholzes, Saar, Herms, Judy Chicago, Ken Price, Larry Bell, and Peter Alexander. It is also the area that subsequently gave us a generation or two of artists who used a broad language of referential and familiar objects, from the museum rare to the gutter common, to bridge ways out of minimalism and postminimalism—Fine, Rubins, Ray, Burden, Kelley, Reiss, Therrien, and Saxe—and subsequently emerging artists who have embraced objects as central to their practice—McCarren, Kersels, Ortiz-Torres, Lachowicz, Pastor, Craft, Meadows, Rhoades, Liz Larner, Evan Holloway, and others. It comes as no surprise indeed that among these names one finds many of the influences, and many of the teachers, of the flourishing generation sampled in this exhibition.

And perhaps, just as the place seems right, the time also seems right for reinvesting in the status of the art object, and the role of the familiar object, in the field of sculpture. As artists of an emerging generation in a fully open postmodern condition begin exploring objects, they do so without the requirement of apologetics for material and consumer indulgence or the need to subjugate the object to the role of prop or 3D visual aid in a conceptual or postminimalist practice. Indeed, the thing for things evidenced by the artists in this exhibition constitutes nothing short of a declaration.

Nathan Mabry's studio with A Touching
Moment (Tooting My Own Horn) (in process,
cat. no. 26), 2004

NOTES

1. Morris discussed such distinctions in his essay "Notes on Sculpture, Part 3: Notes and Non Sequiturs," *Artforum* 5 (June 1967): 24–29; reprinted in Robert Morris, *Continuous Project Altered Daily* (Cambridge: MIT Press, 1993), 23–40. See also Donald Judd, "Specific Objects," *Arts Yearbook* 8 (1965): 74–82; reprinted in Donald Judd, *Complete Writings, 1959–1975* (Halifax, N.S.: Press of the Nova Scotia College of Art and Design in association with New York University Press, 1975), 181–85.

2. Rosalind E. Krauss, "Sculpture in the Expanded Field," in *The Originality of the Avant-garde and Other Modernist Myths* (Cambridge: MIT Press, 1986), 276–90 (quotation from 277); originally published in *October*, no. 8 (Spring 1979): 30–44.

3. Originally published as "Dire Consequences: The Short History of Art as a Liberal Art," *Art Issues*, no. 50 (November–December 1997): 23–27 (quotation from 23); reprinted under the title "The Redemption of Practice," in Libby Lumpkin, *Deep Design: Nine Little Art Histories* (Los Angeles: Art Issues Press, 1999), 111–21.

4. See "Escape Attempts," in Lucy Lippard, ed., *Six Years: The Dematerialization of the Art Object from 1966 to 1972* (1973; reprint, Berkeley: University of California Press, 1997), vii–xxii.

5. Krauss, "Sculpture in the Expanded Field," 282.

6. Robert Morris, "Notes on Sculpture, Part 4: Beyond Objects," in *Continuous Project Altered Daily*, 64.

7. Quoted in G. R. Swenson, "What Is Pop Art? Answers from Eight Painters, Part 1," in *I'll Be Your Mirror: The Selected Andy Warhol Interviews, 1962–1987*, ed. Kenneth Goldsmith (New York: Carrol & Graf, 2004), 15–20 (quotation from 16); originally published in *Art News* 62 (November 1963): 24–27, 60–63.

Jedediah Caesar
Geode, 2004 (detail)
Mixed media
18 x 40 x 48 in. (45.7 x 101.6 x 121.9 cm)
Altoids Curiously Strong Collection

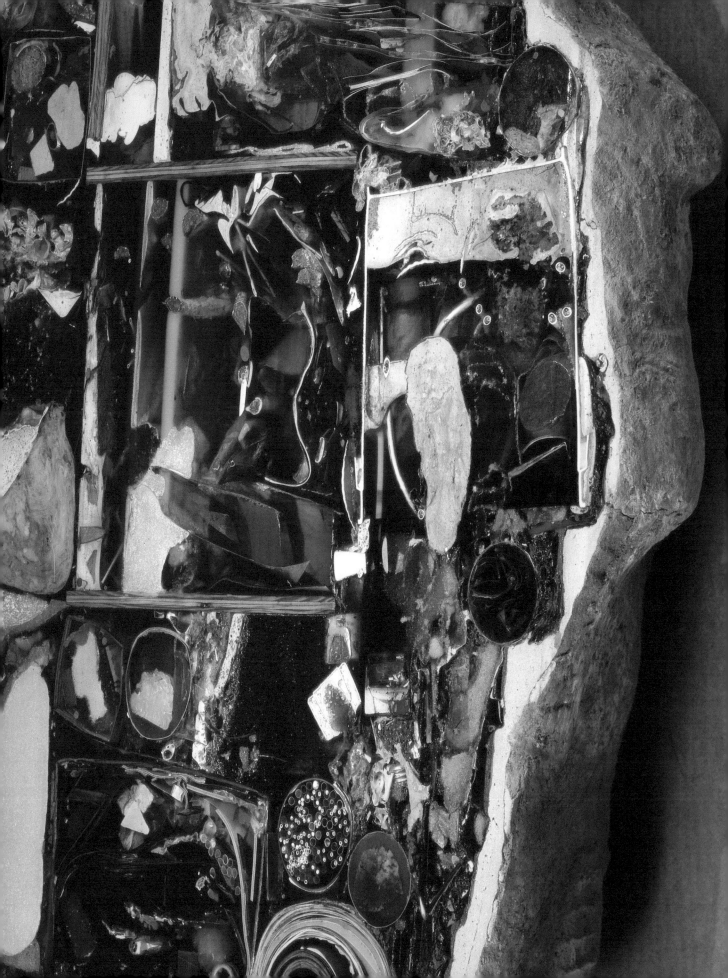

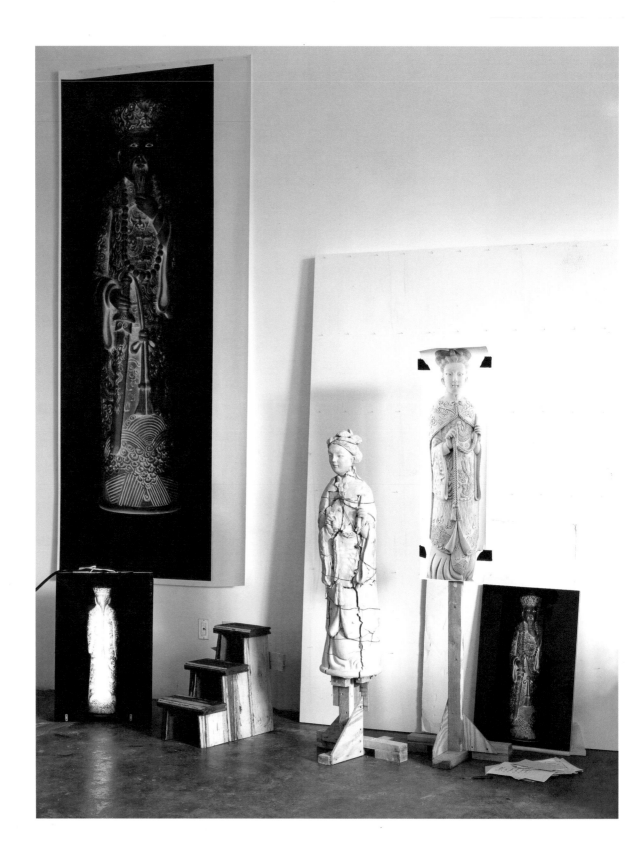

Lauren Bon's studio, 2004

Lauren Bon

The search for place and being is perhaps the one unifying theme found throughout the work of Lauren Bon. In her Hand Held Objects (2000–present), Bon gives form to this search by casting blocks of plaster, from which she carves shapes that fill the negative space in and around her hands, held in a variety of simple positions. At first the sculptures look like alien or prehistoric forms, but after further investigation you can start to see or feel, if you pick them up, that they are more intimate than that, that they were possibly made for the hand that holds them.

In *Wise Elders* (2004), the search continues in a different form. Two nine-foot-tall monoliths of black acrylic resin stand facing each other. They allude to the history of Los Angeles minimalism, specifically the work of John McCracken, who said, "I am after a physical object that appears to be nonphysical, hallucinatory or holographic."[1] Bon has taken the form and precision of minimalism and pierced its cold armor with a lancing stare from a strange figure floating within, giving McCracken's intent a literal presence. But who are these entities, and what do they represent? Are they just images of found objects from a souvenir shop in Chinatown, preserved in a glorified state, or could they be metaphors for something much deeper than their $12.99 price tag suggests? In Stanley Kubrick's *2001: A Space Odyssey*, an enormous black monolith is discovered first by apes on earth and then, millennia later, by humans on the moon. These imposing structures, anonymously planted by some alien force, symbolize the spiritual unknown, offering eternal hope or perhaps the threat of persecution from a higher intelligence. Let's face it: life, death, and creativity are all fantastic mysteries to us. Through her materials and metaphors, Bon searches for her and our place in and connection to this strange world and the universe beyond.

Notes

1. Quoted in the press release for *John McCracken: New Sculpture*, David Zwirner, New York, January 15, 2004, available online at http://www.davidzwirner.com/press.htm (under "Press Releases 2004").

Lauren Bon was born in 1964 in New York City. She received her BA from Princeton University; studied with Rem Koolhaas at the Architectural Association, London; and completed her master's of architecture at Massachusetts Institute of Technology. Since 1992 she has been the founding director and curator of the Hereford Salon, a nonprofit exhibition space in London. Her work has been exhibited at the Freud Museum, London; the Museum of Modern Art, Belfast; Miller Block Gallery, Boston; and the Santa Monica Museum of Art, Santa Monica, California.

JAMES ELAINE

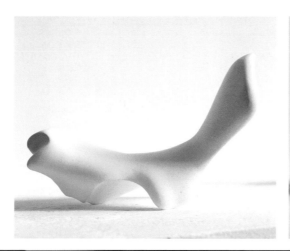
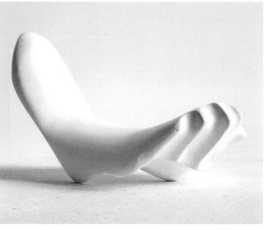

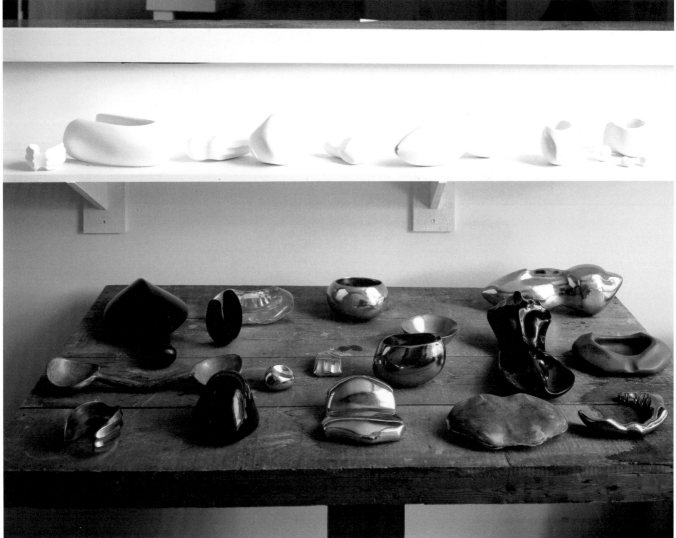

top and bottom: Lauren Bon
Hand Held Objects, 2000–present
Plaster, stainless steel, resin
Dimensions variable
Courtesy of the artist

Photographs used for Lauren Bon's *Wise Elders*, 2005
(cat. no. 1)

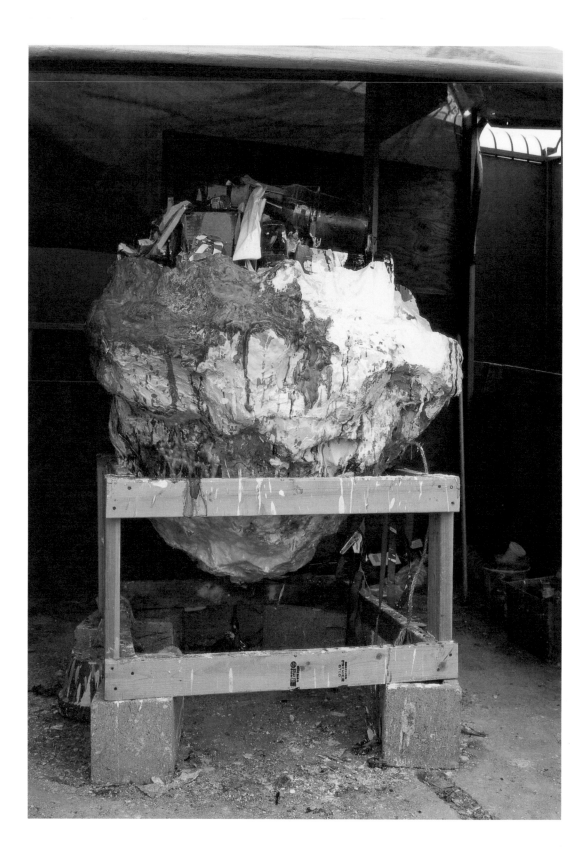

Jedediah Caesar
1,000,000 A.D., 2005
(in process, cat. no. 2)

Jedediah Caesar

Jedediah Caesar has made several sculptures that open up his studio in a way that blurs the boundaries between a supposedly private studio practice and the public nature of an art exhibition. In *Animal Life* (2004), objects Caesar considers as occupying a zone somewhere between studies for sculptures and finished works are displayed on a shelf. This mode of presentation calls attention to their uncertain status along the usually well-defined timeline of artistic production.

In Caesar's geodelike sculptures, the time taken to create, collect, and alter objects is set against a different scale of time: that of natural growth, decay, and eventual geological transformation. Encased in the resin of the pieces are a number of objects from his studio: maquettes and studies for sculptures, containers, and other aesthetically striking debris. *1,000,000 A.D.* (2005) is an extension of an earlier work, *Geode* (2004), which was split in half, and the two halves were exhibited simultaneously in New York and Los Angeles. The sculpture exists as an imperfect multiple, each half of the cross section being a mirror image of its opposite. Instead of being halved, *1,000,000 A.D.* is cut into thin slices, mimicking souvenir geodes at a much larger scale. The slicing creates a framework in time and space: each slice carries echoes of the previous one, and the viewer works to visually reconstruct the splayed objects. Slicing becomes a form of animation, and the sequence of "frames" creates an illusion of time.

Jedediah Caesar was born in 1973. He received his BFA from the School of the Museum of Fine Arts, Boston, in 1998 and his MFA from the University of California, Los Angeles, in 2001. Recently he has had solo exhibitions at Black Dragon Society, Los Angeles, and Hiromi Yoshii Gallery, Tokyo. His work has also been included in group exhibitions at Lombard-Fried Fine Arts, New York; Andrew Kreps Gallery, New York; and Roberts and Tilton Gallery, Los Angeles.

MATTHEW THOMPSON

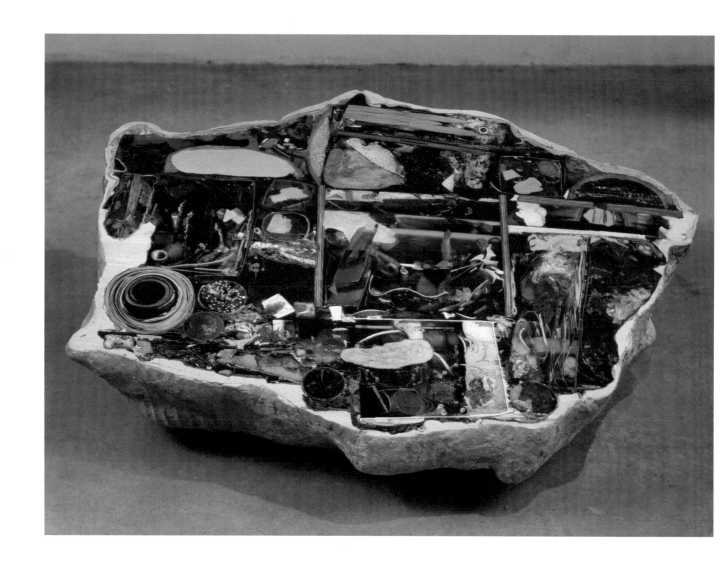

Jedediah Caesar
Geode, 2004
Mixed media
18 x 40 x 48 in. (45.7 x 101.6 x 121.9 cm)
Altoids Curiously Strong Collection

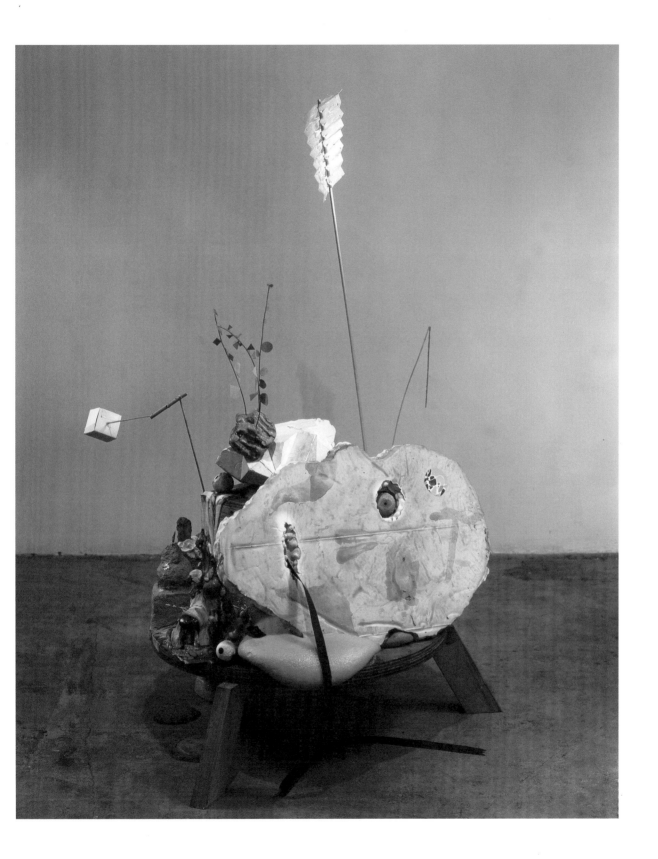

Jedediah Caesar
Animal Life, 2004
Mixed media
55 x 36 x 36 in. (139.7 x 91.4 x 91.4 cm)
Courtesy of Black Dragon Society, Los Angeles

Kate Costello's studio, 2004

Kate Costello

Like unkempt topiaries that could use a clarifying trim, wax museum displays after the air-conditioning has broken down, or sandstone statues that have endured too many years of wind and rain, Kate Costello's sculptures often deal in degrees of removal or distance between a representation and the lost or obscured details of its referent. They force a consideration of two positions: what, for lack of a better term, we might call "heavy abstraction," in which a representation is abstracted to an extreme state but remains linked to that which it still vaguely suggests, and "pure abstraction" or "nonobjectivity," which implies form or composition that refers to nothing but itself, at most giving rise to associations as a Rorschach blot might. Costello's works force a polarization of these two positions—which really should be close neighbors at one end of a broad spectrum—and leave their viewers in a liminal position between. Her objects strangely push the limits of nonobjectivity, a term loosely derived from the German word *gegenstandslos*, which might more accurately be translated as "without objects" or "objectless."

Teetering on becoming objectless objects, just one step outside the category of what Donald Judd called "specific objects" or "three-dimensional work"—objects that refer only to themselves—Costello's pieces take a step into a territory in which something begins to suggest something else (or we begin to see something else in it), and often that something else, more than anything else, seems to be sculpture itself. In *Thing*, Costello exhibits a collection of curious abstractions formed of mixtures of cellulose and cement, which leave one guessing as to what kind of animal or object the sculpture represents or whose portrait it might be. But these—along with other vaguely allusive works she has made of materials such as plaster, ceramic, wood, and fiberglass—refer more specifically to the genres of sculpture—including equestrian statues, portrait busts, architectural ornaments, and minimalist objects—which are both their estranged relatives and their distant referents. Also sampled in the exhibition are Costello's works in pigment-infused plaster cast from busts modeled in clay, which push further into the territory of figuration in an investigation of the relationship between character representation and style.

Kate Costello was born in 1974 in Newfane, Vermont. She completed her BA at Tufts University, her BFA at the School of the Museum of Fine Arts, Boston, and her MFA at the University of Southern California. Her work has been exhibited at Storage in Los Angeles and in the exhibitions *Nature Study* at Todd Madigan Gallery, California State University, Bakersfield; *Free Roaming* at 4F Gallery in Los Angeles; and *High Desert Test Sites 2* in Joshua Tree, California.

CHRISTOPHER MILES

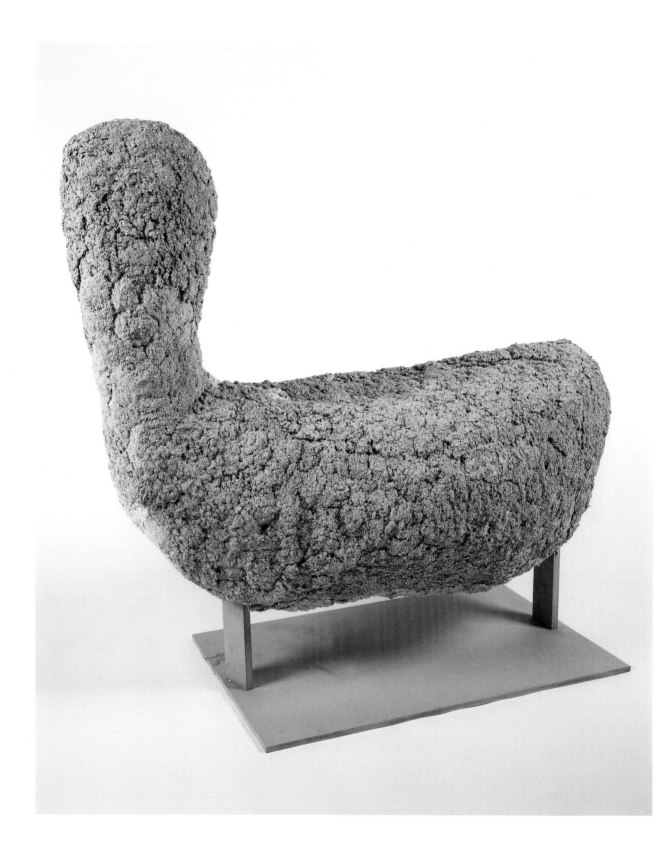

Kate Costello
Untitled, 2002 (cat. no. 3)

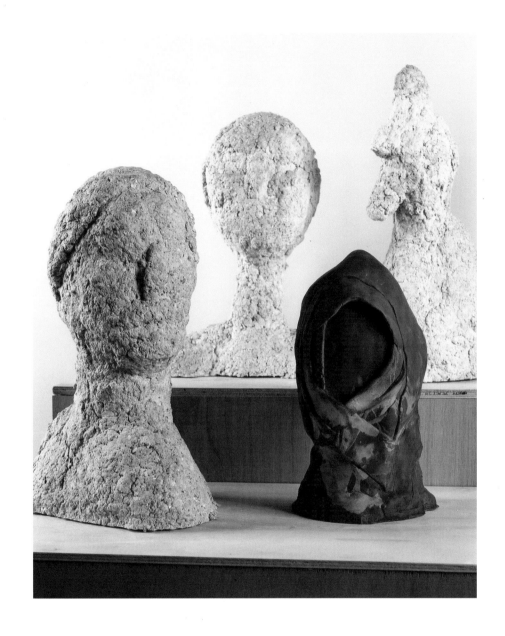

Kate Costello
Portrait Gallery, 2003–present (detail, cat. no. 4)

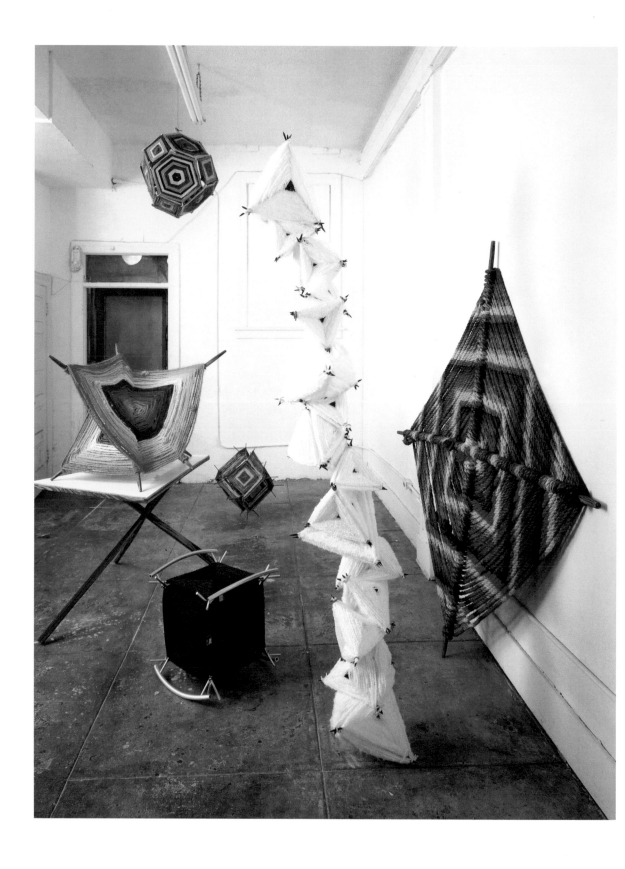

Krysten Cunningham's studio with (foreground, left to right, on floor) *Matter Sucks Matter* (cat. no. 5), *Metaphysical Lunchbox* (cat. no. 6), *Infinity Is Fuzzy* (cat. no. 9), and *Stella's Eye* (cat. no. 8), 2004

Krysten Cunningham

Unlike the God's eyes[1] that Krysten Cunningham's pieces evoke, her work is fully three-dimensional, emphatically breaking with the flatness of traditional weaving. Citing 1920s constructivist artists such as Karl Ioganson and Naum Gabo, Cunningham uses unassuming techniques and materials—wood, yarn, rope, plastic, and paint—to explore the explicitly sculptural concerns of scale, line, space, color, and form. Her *Matter Sucks Matter* (2004) is created from two intersecting woven planes balanced on top of a three-legged table with an irregular polygonal surface. Seeming to reference, if somewhat irreverently, both tabletop sculpture and sculpture on pedestals, the top half of the work dwarfs its seemingly precarious support. In contrast to the cubic solidity of traditional bases, Cunningham's table, with its three intersecting legs, is all geometric line—each leg appears as a vector extending through space, which, combined with the intersecting lines of the top structure, creates an imaginary web.

Emphasizing her interest in the difference between line and space, Cunningham hand-paints her sculptures, ensuring that the colors fade one into the other concentrically along the plane, rather than along the line of the woven rope. This is most evident in *Stella's Eye* (2004), in which the color application runs counter to the woven pattern. In spite of these seemingly esoteric concerns, her work also evokes the utopian visions of the constructivists, Buckminster Fuller, and the American back-to-the-land movement of the 1960s and 1970s, including its adaptation of traditional indigenous crafts. Raised on a commune in Virginia, Cunningham remembers that during her childhood people were "always building things in weird shapes." Her works bring together the traditional concerns of sculpture and this tradition of "weird shapes," attempting, in her words, to bring about a "right brain/left brain" confluence.

Notes

1. God's eyes are a traditional craft—thought to have originated with the Huichol Indians in Jalisco, Mexico—in which yarn is woven over two crossed sticks to form a square, eyelike piece.

Krysten Cunningham was born in 1973 in New Haven, Connecticut, and received her BFA from the University of New Mexico and attended the Institute of American Indian Arts in Santa Fe. She received her MFA from the University of California, Los Angeles. Recent exhibitions include a solo show at Sandroni Rey, Los Angeles, and the group exhibition *Rock* at Mark Moore Gallery, Santa Monica, California.

AIMEE CHANG

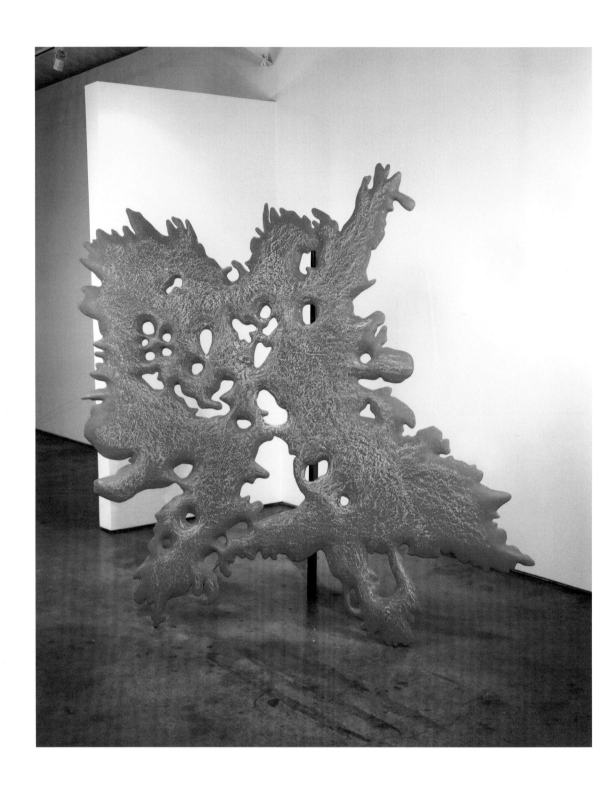

Krysten Cunningham
Wipe-Out, 2003
Polyester resin, pigment, polystyrene foam, zebrawood
76 x 72 x 24 in. (193 x 182.9 x 61 cm)
Courtesy of the artist

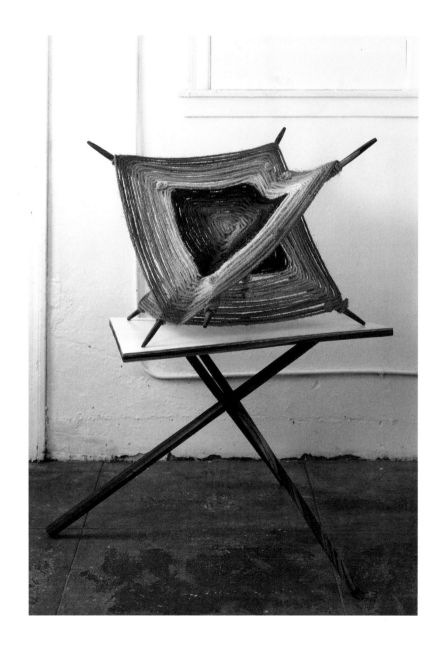

Krysten Cunningham
Matter Sucks Matter, 2004 (cat. no. 5)

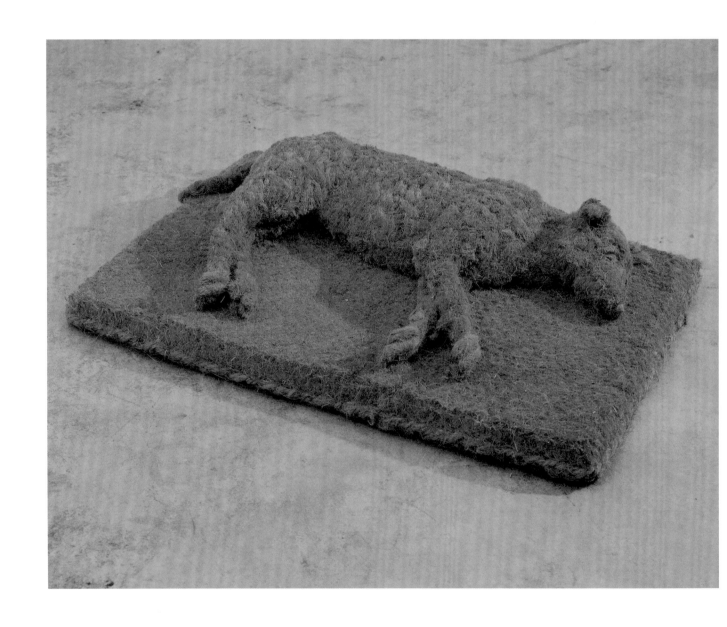

Hannah Greely
Muddle, 2004 (cat. no. 13)

Hannah Greely

Many of Hannah Greely's sculptures provoke anxiety in the viewer. *Assembly* (2001), for example, is a papier-mâché ladder populated by a group of insects. The ladder's fragility begs the viewer to imagine stepping on the first rung, thus relegating it to a permanent state of potential destruction. In another work, *Silencer* (2002), a toddler cast in flesh-colored urethane rubber is seemingly consumed by a child's coat. With its embroidered eyes and fur-lined hood, the coat is at once a piece of clothing and a menacing animal. In both sculptures the coexistence of humor created through visual incongruity and the bizarre narratives conjured by the relationship of the animals and their environment makes for an uneasy combination. By denying fixity, both physically and psychologically, the works retain a sense of movement and continually propose new possibilities of interpretation. Greely's work suggests that there may be more pleasure in this uncomfortable uncertainty, in the act of trying to decipher these strange scenarios, than in any obvious meaning that could be gleaned from the work.

One of Greely's recent works, *Muddle* (2004), combines a languid stray dog and a doormat made from the fibers of coconut shells, two fixtures of the streets of Bangkok that struck the artist during a recent visit to the city. As with her other sculptures, the ambiguity in the relationship between a mute, disempowered creature and its environment generates the work's narrative possibilities. For Greely, animals become screens for emotional projection precisely because they can't communicate verbally.

Hannah Greely was born in 1979. She received her BFA from the University of California, Los Angeles, in 2002. She has had solo exhibitions at Black Dragon Society, Los Angeles, and Andrea Rosen Gallery, New York. Her work has been included in group exhibitions at Grant Selwyn Fine Arts, Los Angeles; Black Dragon Society, Los Angeles; and Deitch Projects, New York. In 2003 her work was included in the Venice Biennale.

MATTHEW THOMPSON

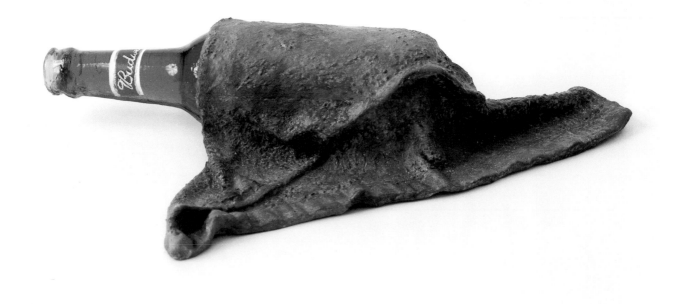

Hannah Greely
Joe, 2004 (cat. no. 11)

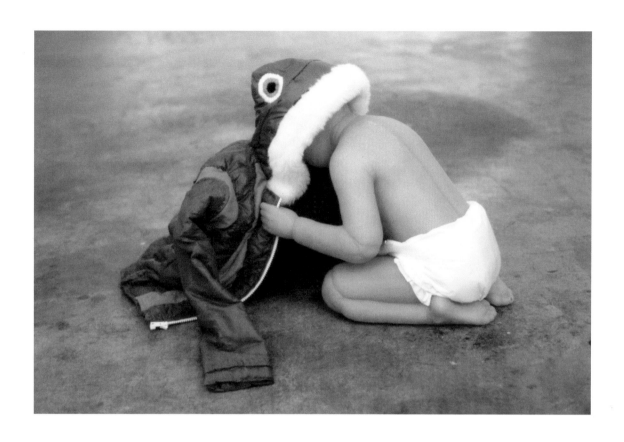

Hannah Greely
Silencer, 2002
Urethane, rubber, nylon fabric
36 x 24 x 18 in. (91.4 x 61 x 45.7 cm)
Collection of Dean Valentine and Amy Adelson, Los Angeles

thing 37

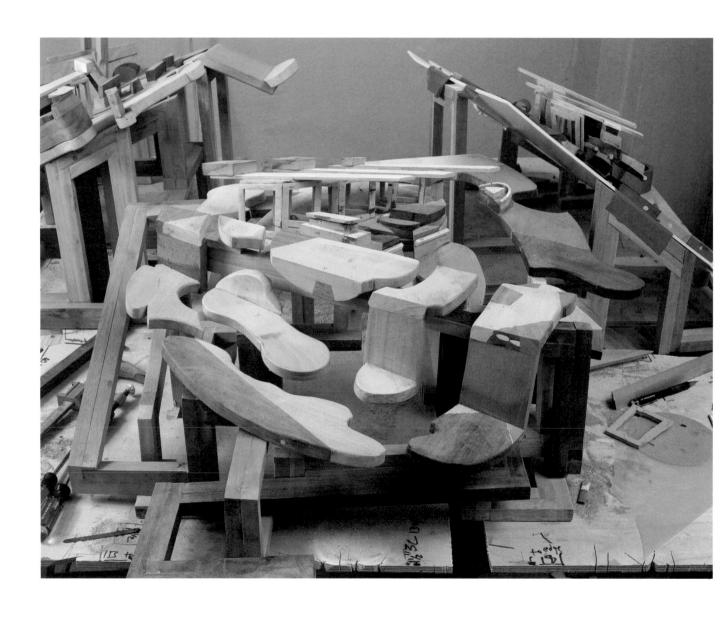

Taft Green
*Reaction Facets: International Seaport; Port 1 of 2; energy distribution,
holding light*, 2005 (in process, cat. no. 14)

Taft Green

Taft Green investigates sites where our experience is highly regulated through routine: checkout counters, airport terminals, and street intersections. Through shifts in scale, point of view, and temporal orientation, his works make apparent the complexity of our interactions with these hyperplanned spaces.

For *Thing*, the artist has created a model of a seaport with different vantage points on either side. *Reaction Facets: International Seaport; Port 1 of 2; energy distribution, holding light* (2005) is based on the way, according to Green, that "light within the visual field transforms into a mental impression and a resultant interpretation." For Green, the seaport exists as a site of large-scale physical organization. The sculpture is nested in a cloth rendering of Jan Vermeer's *View of Delft* (c. 1660–61), itself a depiction of a bustling port. Just as Vermeer used a physical substance (paint) to render the perceptual qualities of light, Green employs unfinished wood to map out the distance between a concrete space and our experience of it. The sculpture registers both the physical trace of a seaport and a conceptual model of subjectivity. As one moves around the sculpture, the view zooms and shifts, preventing a viewer from fixing his or her own position within the constructed space. Green has incorporated this sense of drift into the material itself, building the structure from Brazilian mahogany, poplar from the East Coast, and other wood imported to Los Angeles from elsewhere.

Taft Green was born in 1972. He received an MFA from Art Center College of Design in 2001. He recently had a solo exhibition at Richard Telles Fine Art, Los Angeles, and his work has been included in group exhibitions at the University Art Museum, California State University, Long Beach, and the Museum of Contemporary Art, Chicago.

MATTHEW THOMPSON

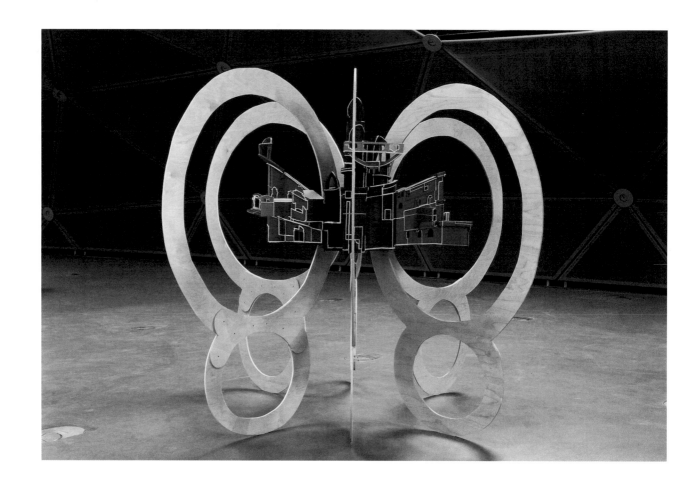

Taft Green
Continual Distance: Arriving at Inbetween, 2003
Mixed media and wood
72 x 84 x 78 in. (182.9 x 213.4 x 182.9 cm)
Collection Kunsthaus Graz, Graz, Austria

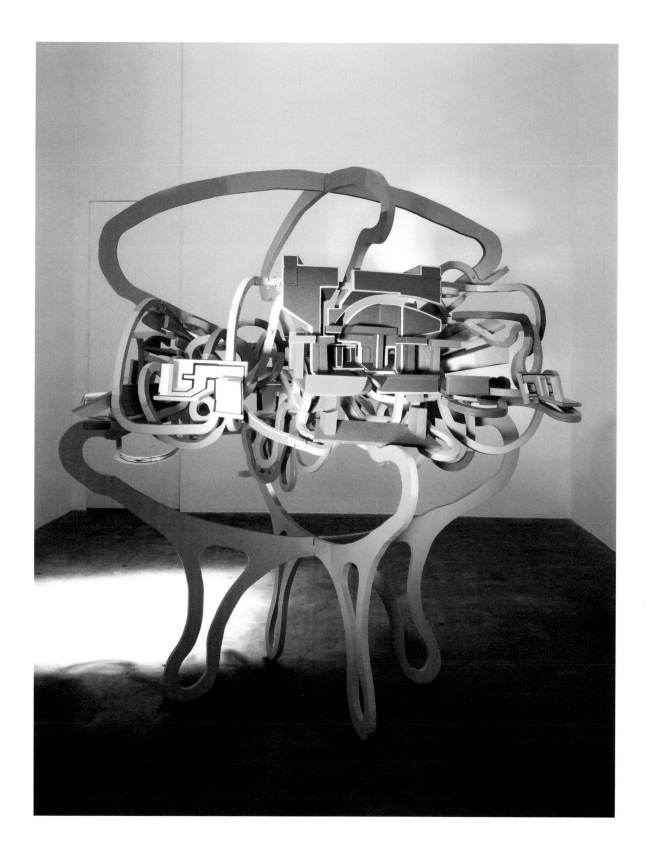

Taft Green
Reaction Facets: international airport, 2004
Wood, acrylic paint, hardware
Height: 74 in. (188 cm); diameter: 80 in. (203.2 cm)
Collection of the artist; courtesy Richard Telles Fine Art

Matt Johnson's studio with *Seaweed Sculpture* (in process, cat. no. 18), 2004

Matt Johnson

Matt Johnson's sculptures could be described as subtle interventions into discrete phenomena that naturally exist somewhere in nature or in our everyday world: a cut orange peel lying on someone's floor, a pile of change, a piece of bread left on a kid's plate after lunch, a stack of ice cubes, a rock with strange veins marbling the surface spelling out the word *wow*, and so on. We may not see it, but Johnson does, and his interplay is just enough to cause us to notice it too. Not wanting to ripple the surface too much, he only hints at his findings, leaving us with the prospect and possibility that this object, now a sculpture, already exists out there in nature. Johnson is in the business of suggesting possibilities and leaving us to marvel at their existence.

Two Orange Peels (2003) was made by cutting and positioning two orange peels, then casting them in bronze. They are painted so realistically that they appear to revert back to their original state. The twist here is that it is possible for the orange peels to hold their shape only because they have been rendered in Johnson's favored material, bronze, a medium that imbues his ephemeral vision with the weight of art history and suggests that hidden within these humble, even silly, objects is the artistic integrity to stand the test of time. In *Puzzle Piece* (2004), a jigsaw puzzle has been slightly enlarged, cast in bronze, and stood on edge like an abandoned drive-in movie screen (or, for those who need an art historical reference, a child's Richard Serra). The romantic image of a setting sun over the sea has been meticulously affixed to the surface piece by piece. You wonder, how does it work? How can it stand there without falling over? One is tempted to see it as a feat of magic, and just as illusion or sleight of hand is what makes magic work, Johnson's sculptures rely on illusion to give them a sense of mysterious possibility.

Matt Johnson was born in 1978 in New York City. He received his BFA from the Maryland Institute College of Art and his MFA from the University of California, Los Angeles. He recently had a solo exhibition at Taxter & Spengemann, New York. His work has been included in exhibitions at the Project, New York; Angstrom Gallery, Dallas; and Happy Lion, Grant Selwyn Fine Art, and ACME, all in Los Angeles.

JAMES ELAINE

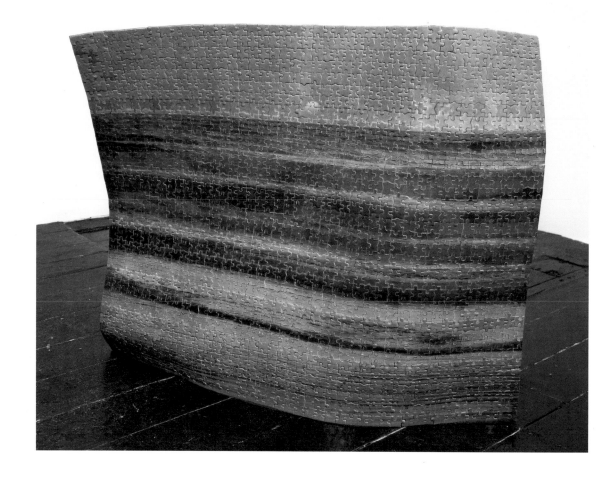

Matt Johnson
Puzzle Piece, 2004 (cat. no. 17)

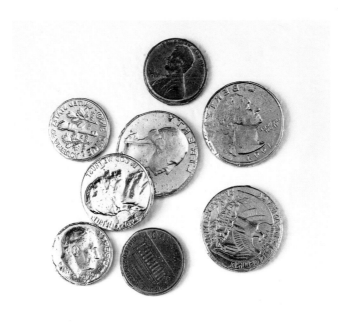

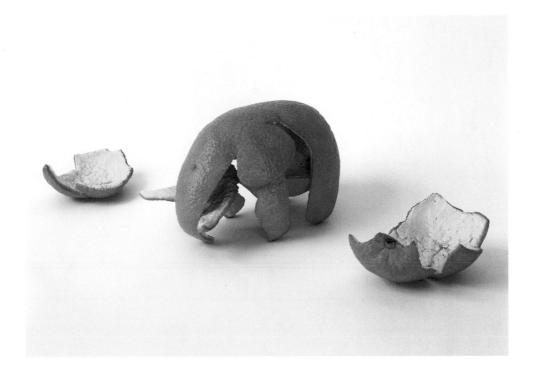

top: Matt Johnson
Change, 2004
Nickel- and copper-plated silver
Dimensions variable
Courtesy of the artist and Taxter and Spengemann, New York

bottom: Matt Johnson
Two Orange Peels, 2003 (cat. no. 15)

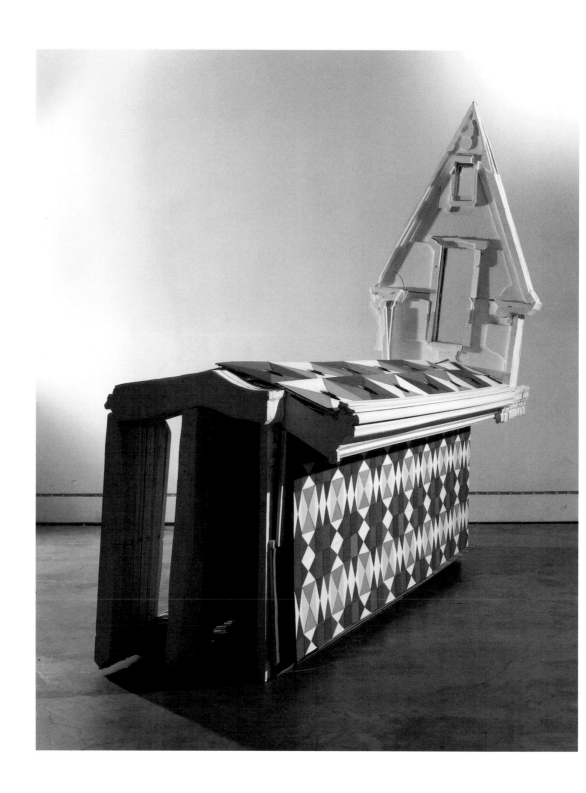

Aragna Ker
In the Spaces of Multiplicity, 2004 (cat. no. 19)

Aragna Ker

Memory and play are important concerns in Aragna Ker's work. Children's board games, jigsaw puzzles, maps, toys, craft materials, quilts, cartoons, and folk art all serve as conceptual source material for him. Several years ago Ker was given a set of building blocks; these brightly colored wooden toys fascinated him. His interest in their material, colors, and the simplicity and repetition of shape overflowed into his work and became a foundational element of his practice. Ker finds materials for his sculptures at common and accessible retail outlets such as craft shops, hardware stores, Home Depot, and Wal-Mart.

A lasting influence from childhood is the ride at Disneyland—found in Fantasyland, of course—called It's a Small World. According to the Disneyland Web site, "global unity is celebrated in this ode to peace and harmony,"[1] and the ten-minute boat ride features costumes, colors, patterns, and songs from around the world. When he made *In the Spaces of Multiplicity* (2004), Ker was looking to build a structure from simple materials, incorporating myriad cultural and decorative influences to create a universal house, a place for and about the global family. Resembling a hybrid of three architectural structures that symbolize key aspects of the life and fate of humans— the home, the church, and the coffin—*In the Spaces of Multiplicity* is a bit rickety and looks to have been repaired and repainted over and over throughout the years. The structure appears to float precariously underneath bright colors and patterns that evoke the flags of the world. Its steeple has long since been separated from its body; only a facade remains, a ghostly echo of time passed.

Notes
1. Disneyland Park, Attractions, "It's a Small World," http://disneyland.disney.go.com/dlr/detail/ attraction?id=itsasmallworldAttractionPage.

Aragna Ker was born in 1974 in Phnom Penh, Cambodia. He received his BFA from the San Francisco Art Institute in 1999 and his MFA from Claremont Graduate University in 2004. In 2004 his work was exhibited at Art Center College of Design, Pasadena, California, and at SWYS, Long Beach, California.

JAMES ELAINE

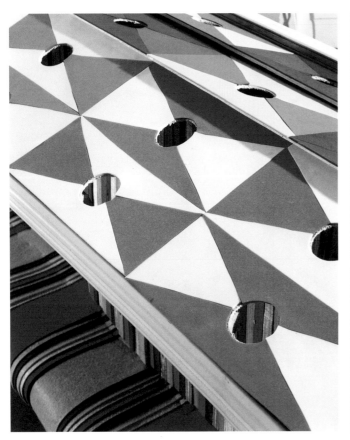

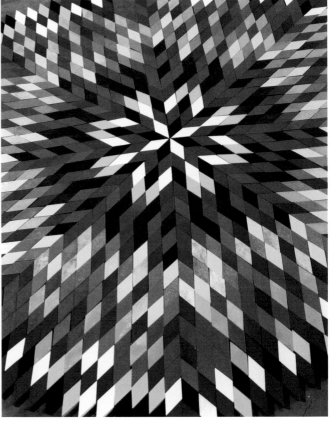

Aragna Ker
In the Spaces of Multiplicity, 2004 (detail, cat. no. 19)

Aragna Ker
Sunburst, 2004 (detail, cat. no. 20)

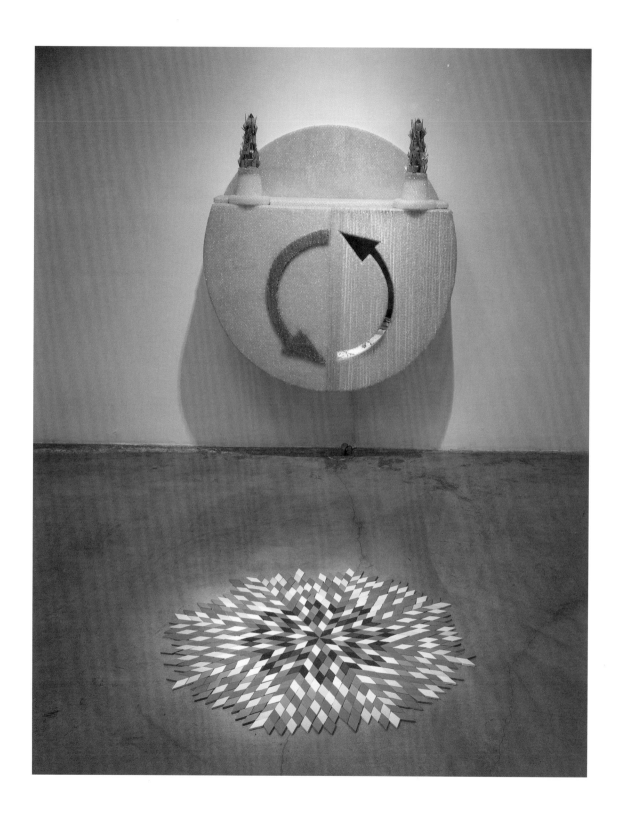

Aragna Ker
This is what I owe, 2004
Wood, foam board, beads, Lite-Brite, poker chips, mirrors, spray paint
Dimensions variable
Courtesy of the artist
Installation view from *The Boy and His Wanders*, 2004, East Gallery, Claremont College, Claremont, California

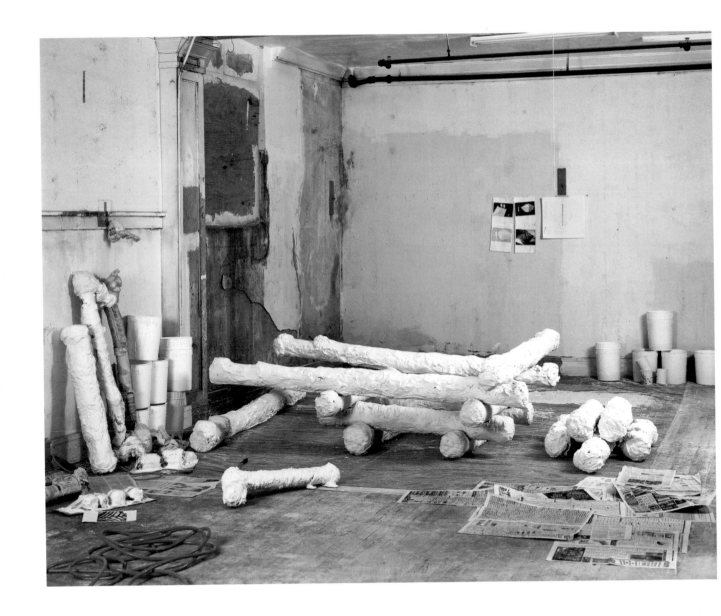

Olga Koumoundouros's studio with *Sagamore: The Good Life* (in process, cat. no. 21), 2004

Olga Koumoundouros

Olga Koumoundouros's works — a pure white cabin constructed from plaster logs; tents in the shape of mountain ranges lashed onto wooden rafts; hand-built, human-scaled shelters and vehicles — are based on American mythologies, especially those of the West. Referencing the frontier, with its seemingly boundless (though false) promise of independence and freedom, her structures explore the place of the physical body and of the individual within these myths. An important part of this investigation has been her ongoing study of American vernacular architecture. During a residency at the Sagamore Institute in the Adirondacks, Koumoundouros concentrated on the history of the log cabin, both as early American housing and in its later manifestation as an architectural and design style.

With its top-heavy construction and precarious balance, *Sagamore: The Good Life* (2005) explores the shaky state of the values — identified by Koumoundouros as purity, integrity, and honesty — symbolized by the log cabin and by the most famous inhabitant of one of these dwellings, Abraham Lincoln. Seemingly embalmed in a plaster casing, the piece also evokes Greek ruins, an association that both ennobles the values that the structure embodies and warns of their possible decline into symbolism and sound bite.

Koumoundouros received her MFA in 2001 from the California Institute for the Arts. Prior to studying there, she received her BA in environmental studies from the University of Vermont and studied at the School of the Museum of Fine Arts, Boston, and at California State University, Long Beach. She recently had a solo show at Adamski Gallery for Contemporary Art in Aachen, Germany, and was included in the exhibitions *New Balance Frontier* at the Soap Factory in Minneapolis and *Up Close* at the Armory Center for the Arts in Pasadena, California.

AIMEE CHANG

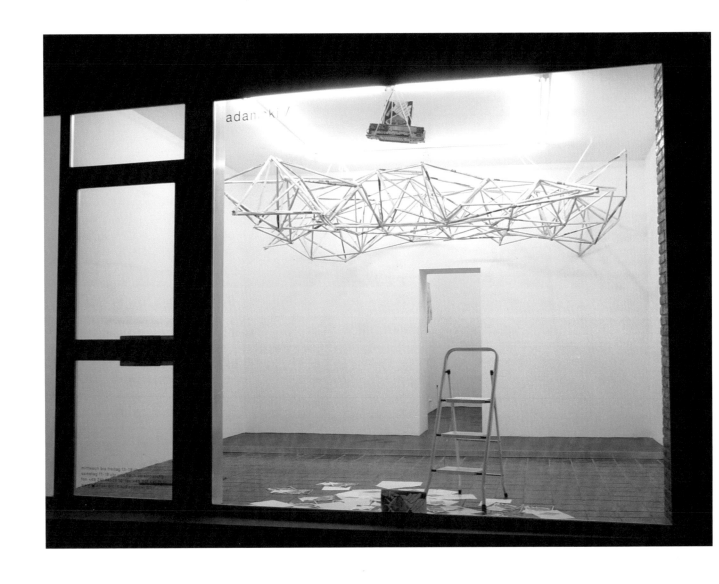

Olga Koumoundouros
Selfmade Man, 2004
Newspaper, hot glue, spray foam, rope, paper feeder, offset poster multiples, step stool
129 5/8 x 157 3/16 x 157 3/16 in. (329.2 x 399.3 x 399.3 cm)
Collection of Gaby and Wilhelm Schuermann, Germany

thing 52

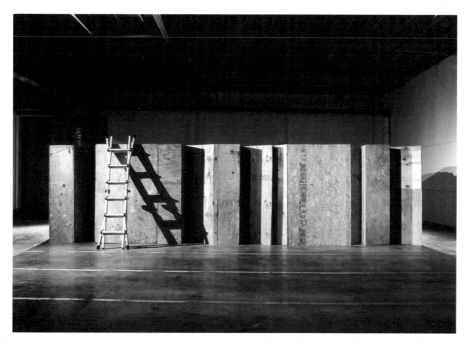

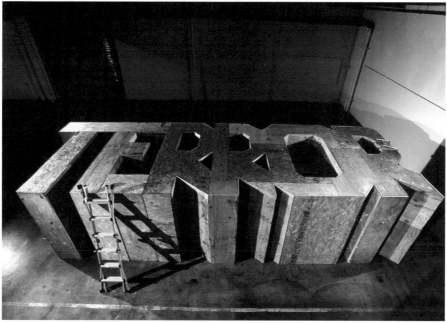

Olga Koumoundouros
Monument to a Town Meeting: After Acconci, 2003
Wood salvaged from demolished high-rise buildings, oriented strand board, fire escape ladder, folding ladder, Formica
72 x 288 x 96 in. (182.9 x 731.5 x 243.8 cm)
Mobberly-Springmeier Collection, Switzerland

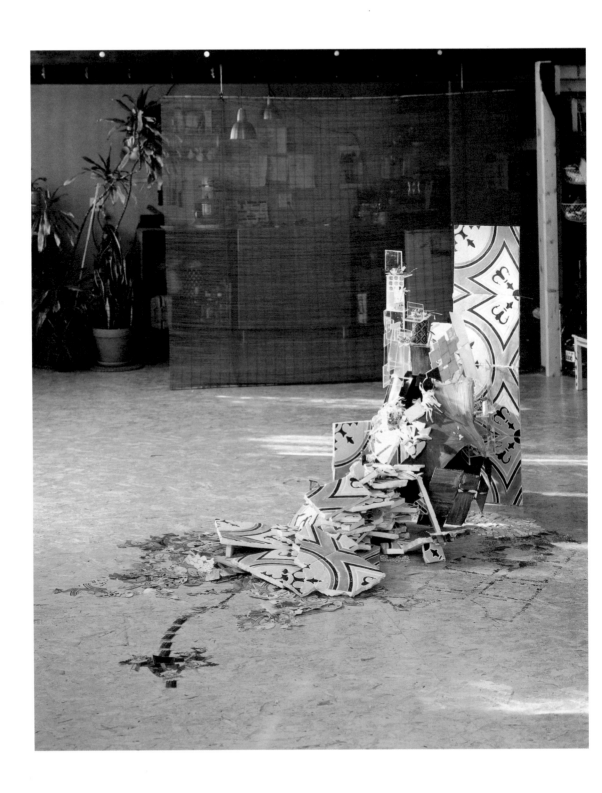

Renee Lotenero
La Casa da Signora Fendi e i Giardini #5, 2004
Handmade tiles, photographs, grape vines, Plexiglas, lacquer paint, steel, paper, found objects
Dimensions variable
Courtesy of the artist

Renee Lotenero

Renee Lotenero uses elements of architectural design as a blueprint for sculptures that are seemingly suspended in an eternal state of flux. As if denying their finiteness, stretching out to be a part of an architectural space, they stand frozen in a state of uncertainty. Are they objects or installations? Are they are in the process of birth and creation or in a downward spiral of death and decay? It is hard to determine, but this is where they are meant to exist.

Steel, wood, paper, cardboard, found objects, and paint are all used in Lotenero's work, but ceramic tiles and photographs are the two most important materials she employs. One is architectural in nature: hard, strong, physical, decorative, three-dimensional. The other is light and transient, a material of memory and recording, a two-dimensional window into a three-dimensional past. After seeing a photograph in a magazine of the Italian designer Elizabeth Fendi's tiled kitchen, Lotenero began obsessively making her own ceramic tiles replicating the designs of the Fendi kitchen as well as other designs she has encountered on her travels around the world. She often takes photographs of the processes involved in the making of her work and then weaves them into the sculptures themselves. Visually the photos mirror the architectural elements, softening their edges and allowing the eye to flow across and through the forms as one medium is transformed into the next. As her work is deinstalled and travels from studio to exhibition space to home, it inevitably changes as it is reconfigured to address its immediate site. There is a playful, haphazard, and spontaneous nature inherent in Lotenero's work, and this unexpectedness and transience are what interest her the most.

Renee Lotenero was born in 1977 in Cleveland. She received her BFA from Art Center College of Design and her MFA from the University of California, Los Angeles. In 2004 her work was included in exhibitions at Art Center College of Design, Pasadena, California; Hayworth Gallery, Los Angeles; and Via Farini, Milan.

JAMES ELAINE

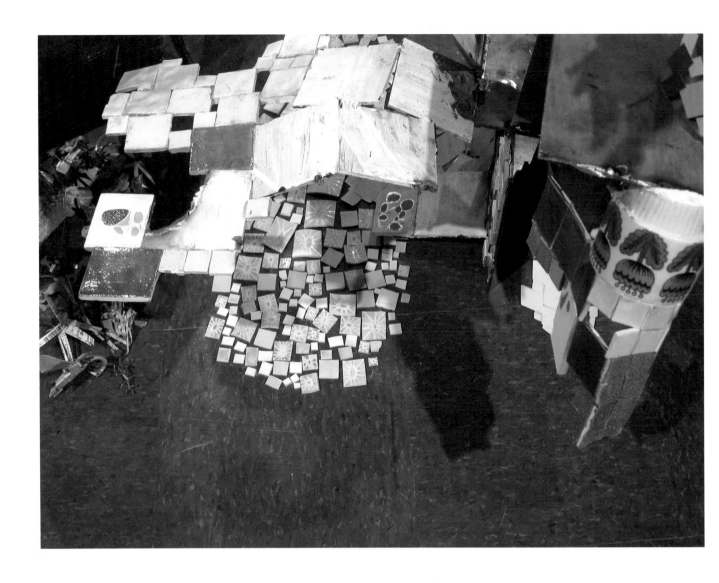

Renee Lotenero
The Club, 2004
Cardboard, steel, tiles, photographs, grape vines, paper, wood, found objects, Plexiglas
Dimensions variable
Courtesy of the artist

thing 56

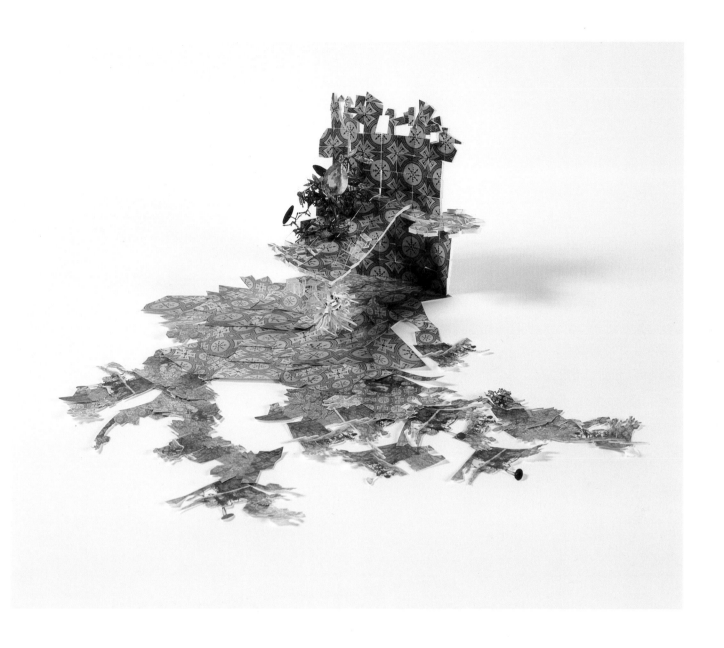

Renee Lotenero
La Piazza Tenera, 2005 (model, cat. no. 23)

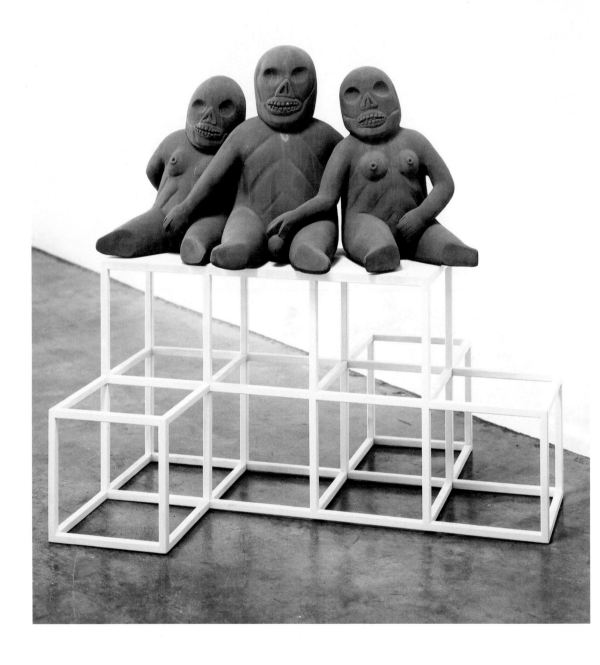

Nathan Mabry
A Very, Very, Very Touching Moment (hear some evil, say some evil, see some evil), 2004
Terra-cotta, steel, paint, diamond
52 x 42 x 30 in. (132.1 x 106.7 x 76.2 cm)
Collection of Marcia Goldenfeld Maiten and Barry David Maiten, Los Angeles

Nathan Mabry

Nathan Mabry works with traditional materials—clay, wood, and plaster—to create idiosyncratic figurative sculptures whose playful use of appropriation and medium-based puns expresses a quirky artistic sense of humor. A recent wall sculpture—porcelain divining rods hung to form the word *madman*—is a comment on Sigmund Freud's remark to Carl Jung regarding the "the black tide of mud of occultism." Mabry created his piece from soft-paste porcelain, a clay that produced the surface he wanted without glazing, allowing him to make the piece entirely from "mud." A similar piece—bones spelling the word *thang*—was made from bone china.

Mabry's approach to appropriation, which he sees as an "opportunity to construct metaphor . . . not merely pastiche," allows him to juxtapose seemingly disparate references. For *A Very, Very, Very Touching Moment (hear some evil, say some evil, see some evil)* (2004), he built three terra-cotta figures based on pre-Columbian Moche ceramics, which often feature erotic subject matter and skeletized figures. The three figures—evocative of the monkeys who hear, see, and speak no evil—are seated on a pedestal resembling the work of Sol LeWitt. The piece is a jumble of references to multiple instances of artistic appropriation, from hip-hop (the diamond-embedded tooth of one of the figures) to modernism's debt to primitivism. The use of minimalist works as pedestals is a recurring theme in Mabry's work, a playful recontextualization of the multiple art historical legacies with which the current generation of artists must contend.

Nathan Mabry was born in 1978 in Durango, Colorado, and lives in Los Angeles. He received his MFA from the University of California, Los Angeles, and his BFA from the Kansas City Art Institute. He has shown recently at cherrydelosreyes in Los Angeles.

AIMEE CHANG

Nathan Mabry
Three-Toed Love, 2003 (cat. no. 24)

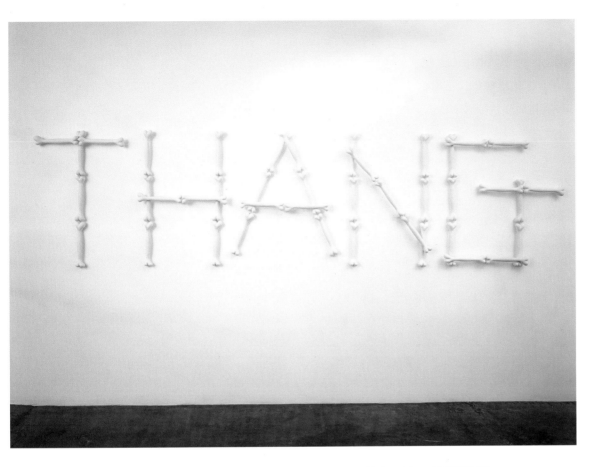

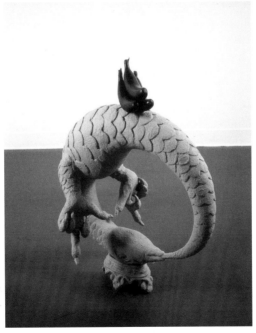

top: Nathan Mabry
THING THANG, 2004 (cat. no. 25)

bottom: Nathan Mabry
Timeless, 2004
Carving foam, FC-90 foam coat, paint
34 x 29 x 30 in. (86.4 x 73.7 x 76.2 cm)
Courtesy of the artist and cherrydelosreyes, Los Angeles

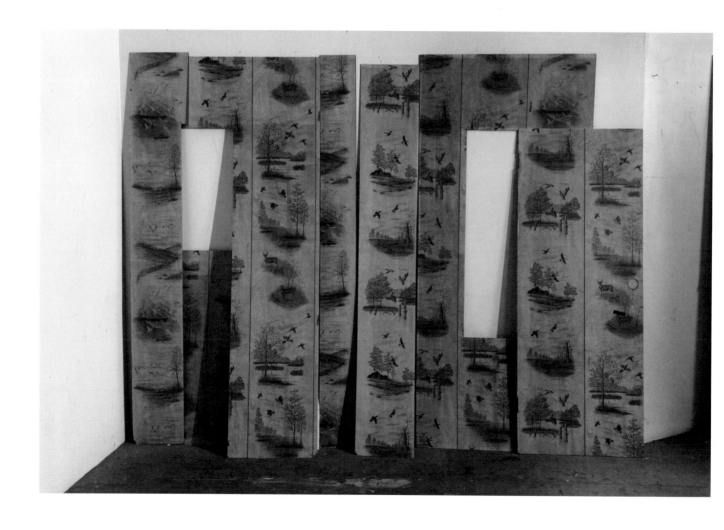

Rodney McMillian
Wood Paneling, 2004 (cat. no. 28)

Rodney McMillian

Rodney McMillian works in multiple media, finding consistency in ideas rather than materials. Recent exhibitions have featured sculpture, video, and painting, along with hybrid works that straddle all three categories. Tying it all together is McMillian's interest in aesthetics as expressed through art and through bourgeois concepts of taste — Martha Stewart's "good life" — and in value, both economic and psychic.

For his sculptures and collaged paintings, McMillian favors domestic detritus — materials too shabby even for Goodwill. *Wood Paneling* (2004) consists of wood paneling installed in a quasiminimalist formation. Resembling an abject Richard Serra piece, the work seems caught between its formal rigor — itself the result of long-forgotten doorways and walls — and its melancholy suburban 1970s-era hunting lodge aspirations.

Like a Duchampian readymade, *Wood Paneling* is installed as found, with a minimum of artistic intervention, casting light on the way in which objects are designated as art. The piece, like other works by McMillian, highlights the consumer context in which all objects are embedded. His choice of materials — shoddy, stained, frayed, *used* — foregrounds their identity as the residue of consumerism, consumption, and disposal. This history imbues his works, following them as they enter the arena of art.

Rodney McMillian was born in 1969 in Columbia, South Carolina, and currently lives in Los Angeles. He received his MFA from California Institute of the Arts and his BFA from the School of the Art Institute of Chicago. In 2004 and 2005 he will have solo exhibitions at Susanne Vielmetter Los Angeles Projects; Triple Candie in New York; Adamski Gallery for Contemporary Art in Aachen, Germany; and Galeria Estro in Padua, Italy. Recent group exhibitions include *White Noise* at REDCAT, Los Angeles, and *Seeds and Roots: Selections from the Permanent Collection* at the Studio Museum in Harlem, New York.

AIMEE CHANG

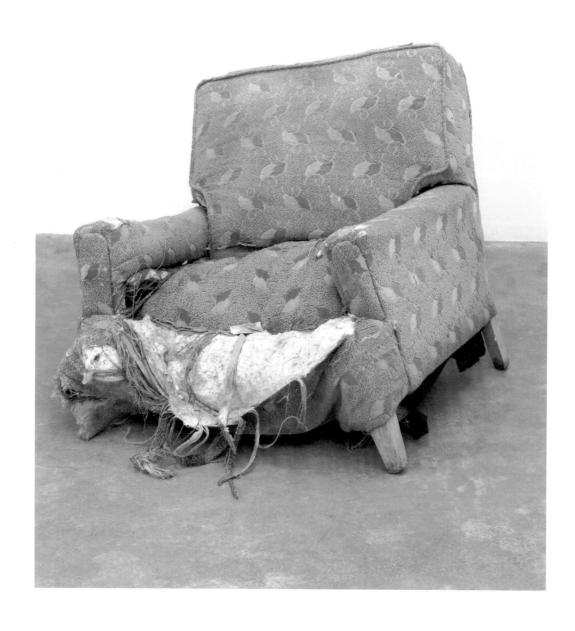

Rodney McMillian
Chair, 2003
Chair
33 x 38 x 33 in. (83.8 x 96.5 x 83.8 cm)
Collection of Gaby and Wilhelm Schuermann, Germany

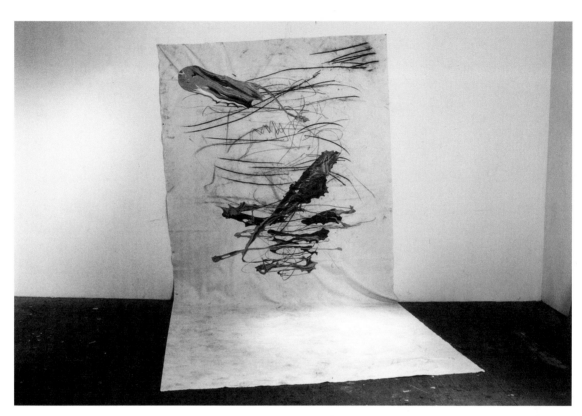

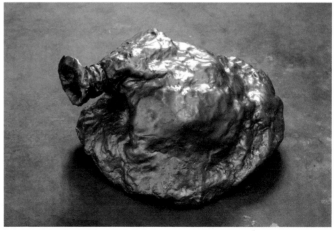

top: Rodney McMillian
Untitled, 2004
Latex paint and charcoal on canvas
84 x 72 x 77 in. (213.4 x 182.9 x 195.6 cm)
Courtesy of the artist and Susanne Vielmetter Los Angeles Projects

bottom: Rodney McMillian
Untitled (Silver Balloon), 2004 (cat. no. 27)

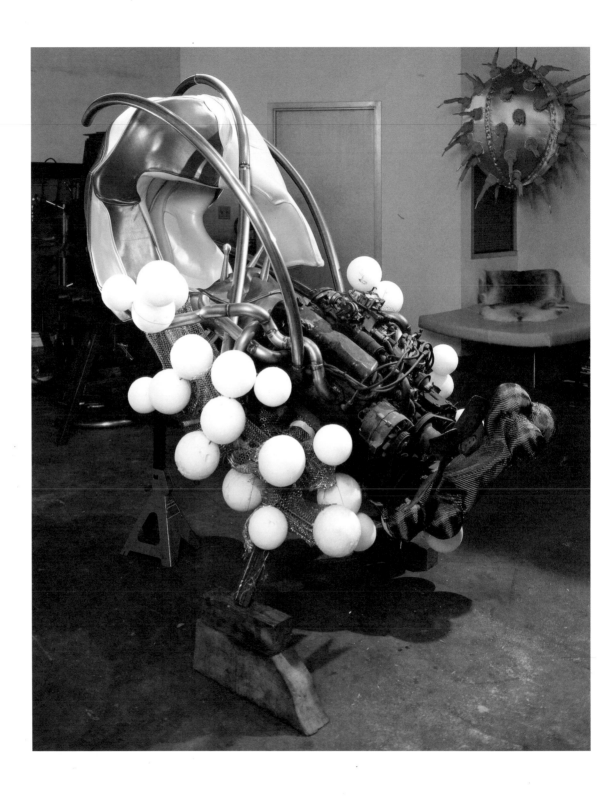

Chuck Moffit
eros bruises thanatos, 2005 (in process, cat. no. 29)

Chuck Moffit

How does form follow function when objects of necessity and utility serve as aesthetic vehicles for anxieties, desires, ideals, and indulgences? In Chuck Moffit's sculptures, one finds stock parts commingled with custom fabrications, modular and standardized units trying to find a fit with unique and unwieldy forms, and simple engineering and construction — whether highly refined or more do-it-yourself and get-the-job-done in nature — wedded with impulses toward sensuality, eroticism, and fetishism. *Conflation*, *confusion*, and *collision* are words that begin to describe his past works, in which one finds the design sensibilities and embedded priorities or ideologies of architecture by the likes of Buckminster Fuller or a Mongolian yurt builder fused with the interests of a van customizer and an obsessed *Barbarella* fan.

Moffit's inclusion in *Thing*, a work made using the materials, processes, and codes of show car and hot rod building, is suggestive of a sperm or a comet caught in suspended animation while hurtling through inner or outer space. Its position suggests that it might be about to crash, be plowing into a field, or be bucking like a bronco. Like the show cars to which it is kin, however, it actually sits on blocks, its dynamism implied only by its aesthetics. It is a "frozen fire," to use a phrase borrowed from a song by the Cars. Moffit's mutant is something of a love child of futurism and custom car culture. Like animals specially bred or physiques cosmetically sculpted for overemphasized attributes, the piece is a fantasy of attributes, a standard model fetishized and engineered down to the basic signifiers of speed, power, and sensuality — custom body work, upholstery, fiberglass, and a V8 engine — a fully functional titillation but a no-longer-viable mutation. In the end its frozen dynamism does not so much suggest an object ready to burst forward as it suggests one struggling to dislodge itself from the inbred language of forms from which it comes.

Chuck Moffit was born in 1969 in West Bend, Wisconsin. He completed his BA at the University of Nevada, Reno, and his MFA at Claremont Graduate University. His works have been exhibited at the Sheppard Gallery, University of Nevada, Reno; Cyndie Maiss Gallery, Reno; and the Brewery Project, Los Angeles. He works as a fabricator for artists, architects, and car enthusiasts.

CHRISTOPHER MILES

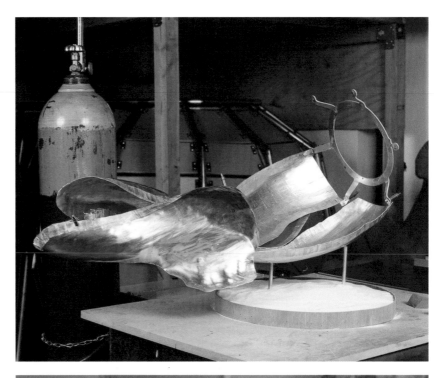

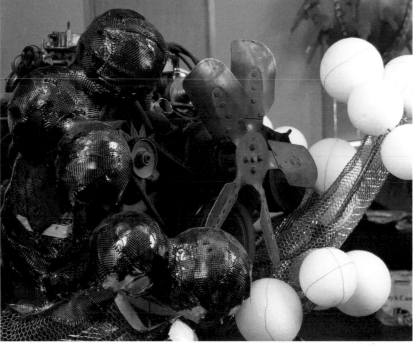

top: Chuck Moffit
Studio model for *eros bruises thanatos*, 2005 (cat. no. 29)

bottom: Chuck Moffit
eros bruises thanatos, 2005 (detail, in process, cat. no. 29)

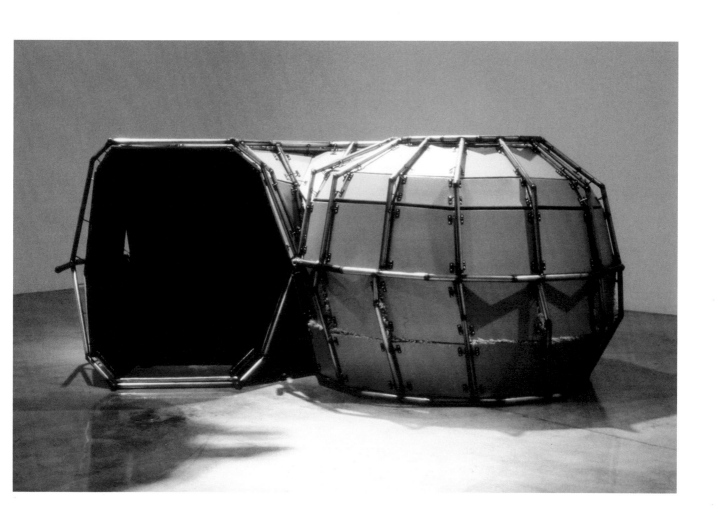

Chuck Moffit
Untitled, 2000
Steel, wood, foam, vinyl, velvet, fake fur
58 x 90 x 135 in. (147.3 x 228.6 x 342.9 cm)
Courtesy of the artist

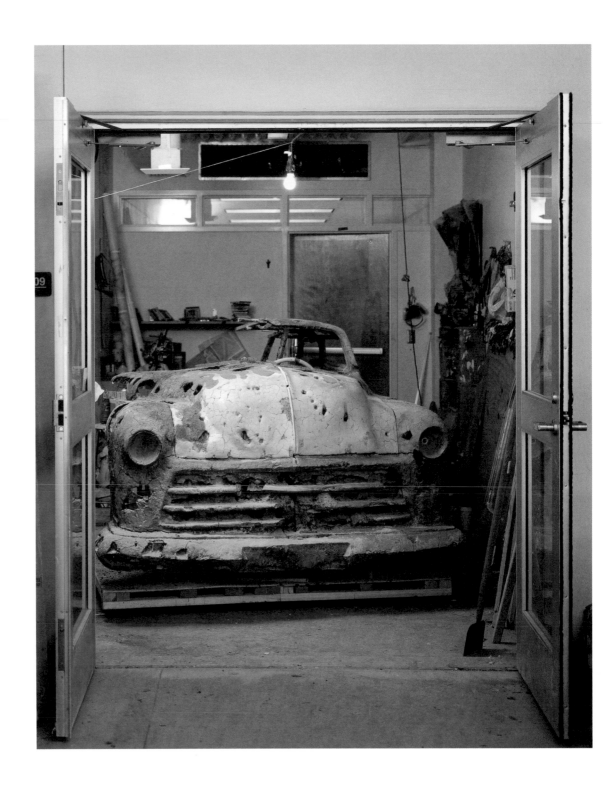

Kristen Morgin's studio with *Sweet and Low Down* (in process, cat. no. 31), 2004

Kristen Morgin

Formed from a mixture of clay, cement, and glue over armatures of wood and wire, Kristen Morgin's sculptures—which are simultaneously placid and elegant, caustic and crude—reference things contemporary and familiar but appear as things unearthed or of the earth. They are so surprising, so uncanny, as to seem without precedent, yet they have affinities with a strange assortment of objects, including ancient tomb guardians like the Qin dynasty terra-cotta soldiers found buried in central China, the revolutionarily unfinished yet finished sculptures of Auguste Rodin, the bricolage towers of Simon Rodia, and the quasirealist sculptures of Liz Craft and Charles Ray. In character, they relate to the assemblages and tableaux of George Herms, Edward and Nancy Reddin Kienholz, and Michael C. McMillen, and to the rougher edges of a category of art that has come to be termed California funk. Like some artists associated with that movement, Morgin comes from a ceramics background, and although her works seem far from what one imagines as "ceramic," they are traditional in some ways. Her life-size sculpted cars and musical instruments, represented in *Thing* by a piano and a chopped and lowered vintage Mercury automobile, are vessels—hollow-bodied forms—and resonate with the long tradition of the ceramic vessel form as metaphor or stand-in for the body, extended in Morgin's case as corpse, mummy, or fossil. And as with bodies, living or dead, we tend to scan them for information and attempt to establish identities and imagine origins and circumstances for them. Morgin's works play into fascinations with the grotesque, the apocalyptic, and even the supernatural, suggesting a variation on the legend of the Golem, the servant/friend/monster formed of raw earth.

Kristen Morgin was born in 1968 in Brunswick, Georgia. She completed her BA at California State University, Hayward, and her MFA at Alfred University. Her works have been included in the *Sixty-first Scripps Ceramic Annual* at the Ruth Chandler Williamson Gallery, Claremont, California, and *Because the Earth Is One-Third Dirt* at the Colorado University Art Museum, Boulder. She is an assistant professor of ceramics at California State University, Long Beach.

CHRISTOPHER MILES

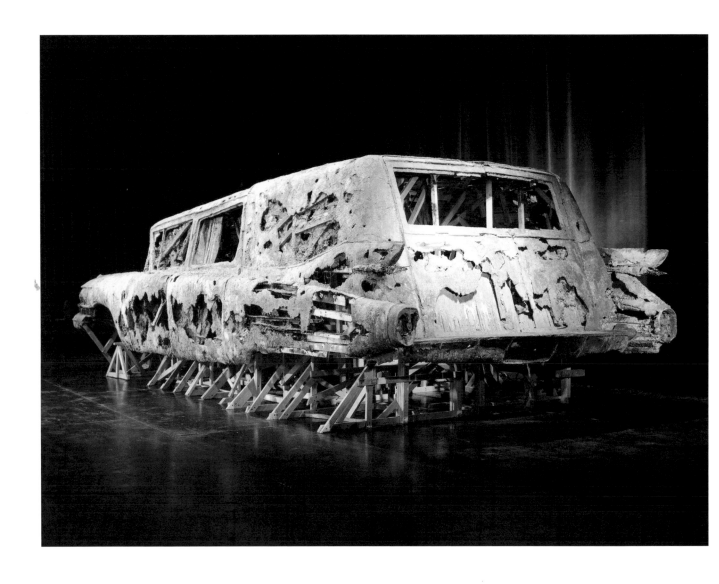

Kristen Morgin
Hearse, 2004
Unfired clay, wood, wire
88 7/8 x 186 x 69 in. (225 x 472.4 x 175.3 cm) (approx.)
Collection of the artist

thing 72

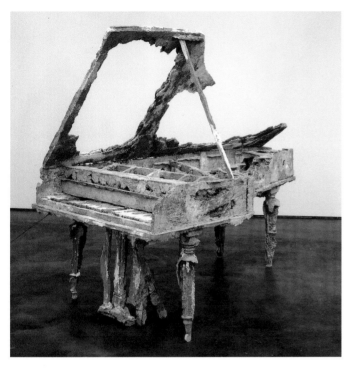
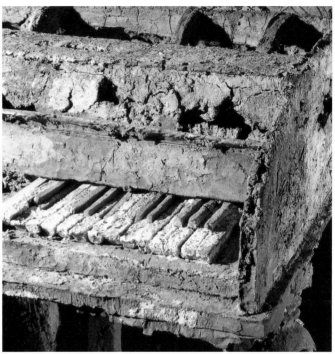

Kristen Morgin
Piano Forte, 2004 (cat. no. 30)

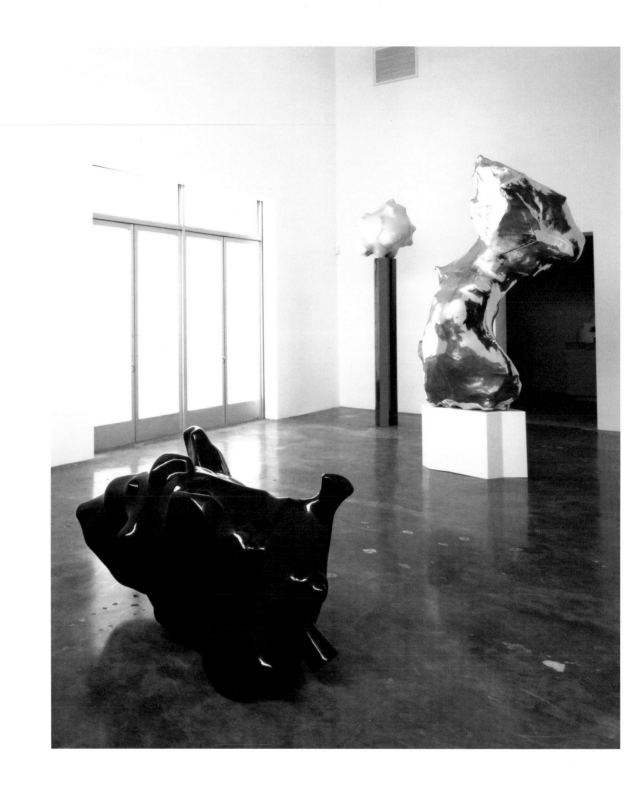

Installation view of Joel Morrison's solo exhibition,
Griffin Contemporary, Santa Monica, 2004

Joel Morrison

Joel Morrison elevates garbage collection to the level of (post)modern sculpture. His slick and dynamic, yet also crude and bumbling, forms are like elegant carcasses and are in fact something like exquisite corpses—drawings in which different artists add elements until an unexpected totality is revealed. Morrison plays this game by himself, amalgamating common objects and castoffs and wrapping them in packing materials and tape to arrive at a complete form. Unsettlingly suggestive of bags full of cats scratching to get out or of scenes from sci-fi movies wherein a "host" realizes that she has something alien growing inside, Morrison's sculptures push the form/content game to a tense standoff between raw content that wants to get out and pure, unifying form that wants to keep it in. Some works split open and spill their guts; others leave clear traces of the binding and corseting involved in pulling the jumbles into shape.

More recently, Morrison has favored casting his works (in some cases, entombing them) in fiberglass or metal. The resulting forms, with bulges echoing familiar shapes like bone structure and musculature beneath skin, still divulge traces of what went into them as well as the spontaneity of their generation, but their immediacy and intensity are slowed and cooled by the smooth, sanded and polished surfaces. Perched on exaggerated Brancusiesque bases, they aspire to the purity of high modernist abstraction, minimalist specificity, and finish-fetish sleekness but arrive at a burlesque, still flaunting their common, found-object insides and their trashy, trampy, scrappy origins.

Joel Morrison was born in 1976 in Seattle. He studied briefly at the Pont-Aven School of Art, Pont-Aven, France; received his BA from Central Washington University; and completed his MFA at Claremont Graduate University. His work has been exhibited at Finesilver Gallery, San Antonio; Ace Gallery, Los Angeles; Griffin Contemporary, Santa Monica, California; and the Project Room at the Santa Monica Museum of Art.

CHRISTOPHER MILES

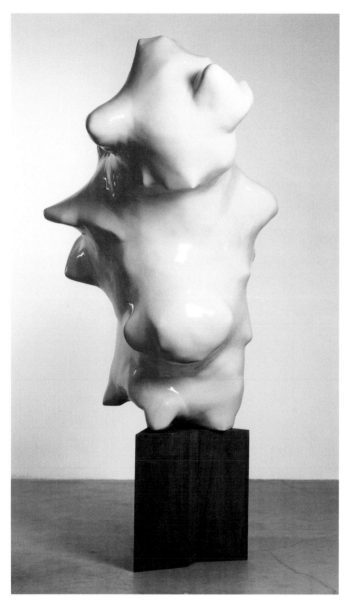

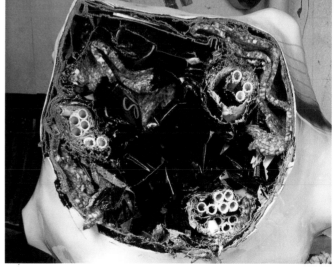

Joel Morrison
Untitled, 2002
Fiberglass, blue paint
90 x 44 x 54 in. (228.6 x 111.7 x 137.2 cm)
Collection of J. Ben Bourgeois

Joel Morrison
Untitled Studio Image, 2004
Mixed media
24 x 48 x 33 in. (61 x 121.9 x 83.8 cm)
Collection of Marcia Goldenfeld Maiten and Barry Maiten, Los Angeles

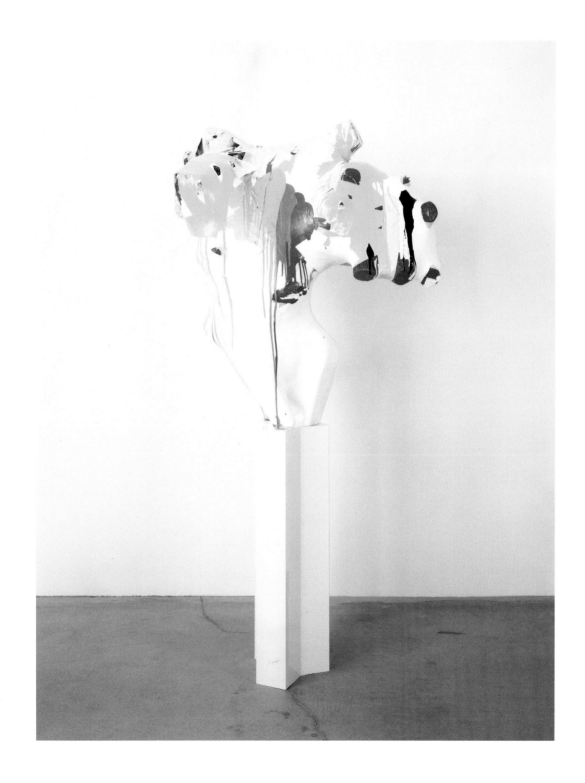

Joel Morrison
Bouquet (a Torso), 2002
Fiberglass, paint, tape, Formica
84 1/2 x 48 1/2 x 31 in. (214.6 x 123.2 x 78.7 cm)
Private collection, Los Angeles

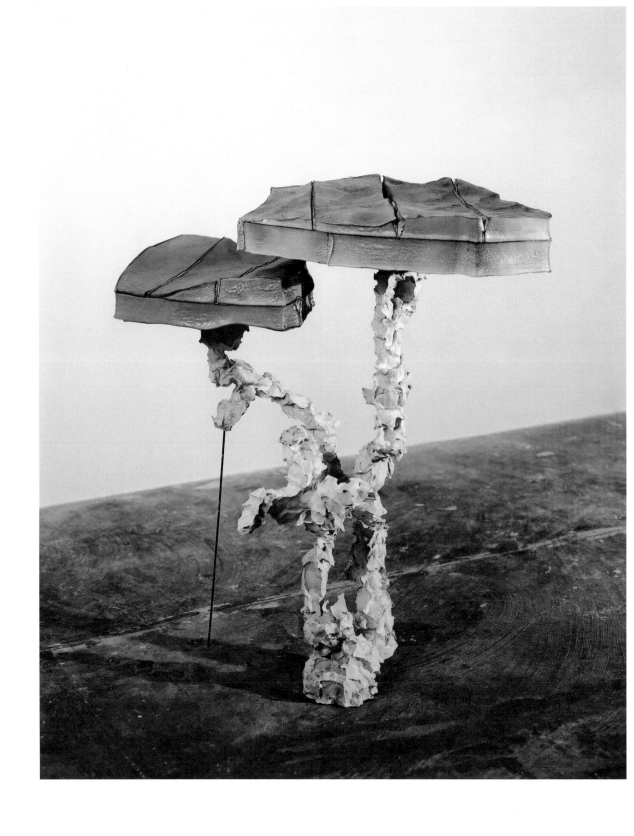

Michael O'Malley
Untitled Object 11.04, 2004 (in process, cat. no. 37)

Michael O'Malley

Michael O'Malley's sculptures disrupt the ways in which small objects related to the body construct and order our experience of daily life. While constructing an Ikea bookshelf, the artist realized that the flimsy, mass-produced objects that permeate our lives can determine us as much as we determine them. By relating his work visually to architectural models, he conflates the way that intention is written into commonplace domestic objects with the manner in which it becomes the starting point for large-scale building projects. His installation *Sprawl* (2003–4), for example, is simultaneously a mazelike bookshelf and an intricate cityscape. In O'Malley's words, "Through strategies of play, pleasure and interaction, my work focuses on the shifting dimensions of the built environment, kinesthetic experience and social relations."

O'Malley is interested in creating work that exists as both a critique and a proposal. His sculptures become models for engagement with one's environment, generating possibilities and multiplying alternatives to ways to relate to the objects and spaces that surround us. Enmeshed in O'Malley's dissection of the built environment is his preoccupation with what he refers to as the "thingness" of sculpture: the manner in which labeling and articulation can fail in the presence of the object. In *Untitled Object 11.04* (2004), this loss of control is integrated into the construction of the work itself. Blue islands of foam, suspended on plaster, were formed with a torch. Given the imprecise nature of such a process, the artist could determine the form and color only to a degree, and the final product is the result of both his intention and the physical and chemical reactions that took place.

Michael O'Malley was born in 1965. He attended Stanford University, receiving his MFA in 1999. He has had solo exhibitions at cherrydelosreyes, Los Angeles, and the Feldman Gallery, Pacific Northwest College of Art, Portland, Oregon. His work has been included in group exhibitions at Smart Project Space, Amsterdam, and the Bellevue Art Museum, Bellevue, Washington.

MATTHEW THOMPSON

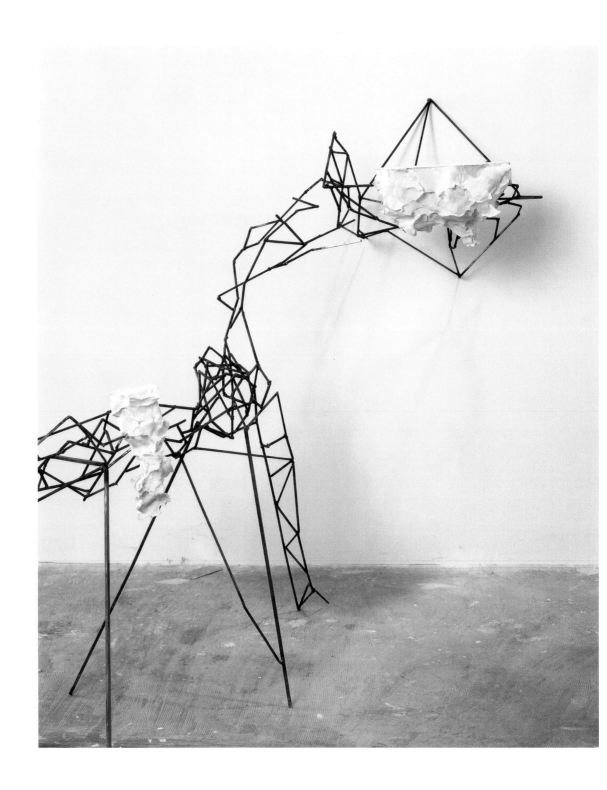

Michael O'Malley,
Untitled Configuration 8.04, 2004 (detail, cat. no. 35)

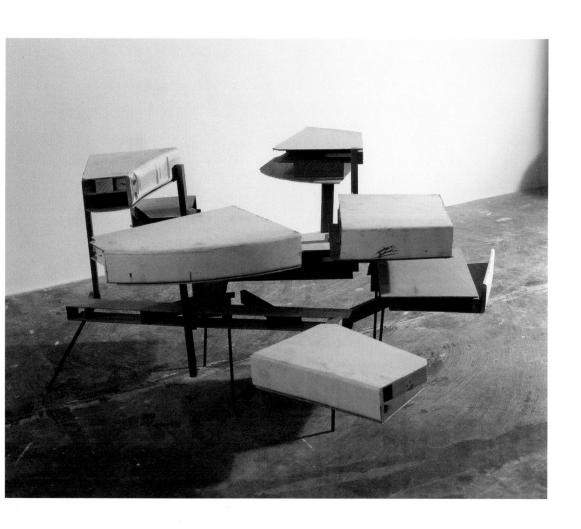

Michael O'Malley
Untitled Object 7.04, 2004 (cat. no. 36)

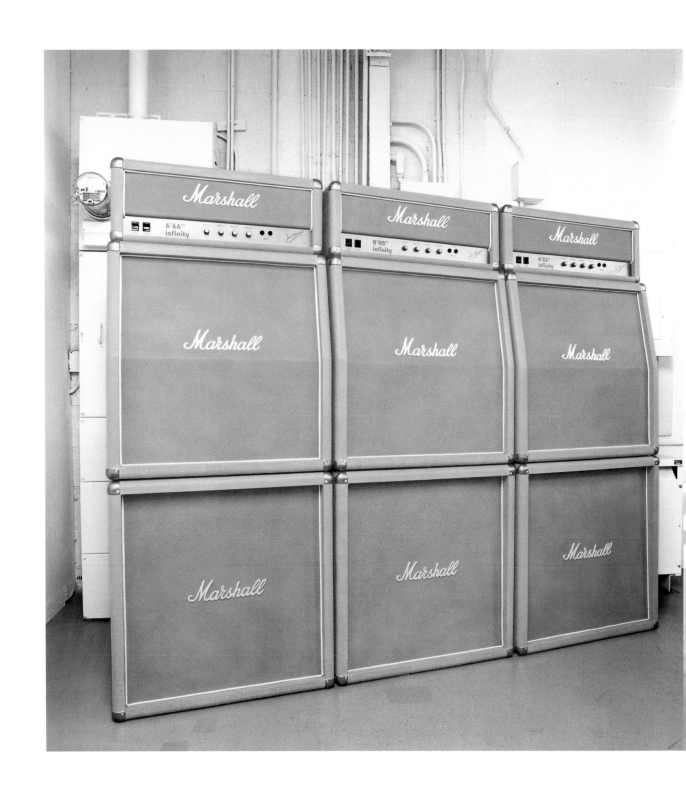

Kaz Oshiro
Pink Marshall Stack Wall (Three Marshall Double Stacks), 2002
(cat. no. 38)

Kaz Oshiro

The sculptures of Kaz Oshiro are not what you see or think you see, and then again they are exactly that. Using paint, canvas, and stretchers, the expected materials of a painter, as well as Bondo, an auto-body filler that is a staple of California car culture, Oshiro paints hyperrealistic still lifes in three dimensions of common objects from pop and commercial culture, achieving very unexpected results.

Pink Marshall Wall (2002) is from a body of work that pays homage to Oshiro's early influences and passions: primarily John Cage, experimental music, and punk rock but also the work of artists Donald Judd, Ed Ruscha, Andy Warhol, and Ed "Big Daddy" Roth, as well as curator Paul Schimmel's groundbreaking 1992 exhibition at the Museum of Contemporary Art, Los Angeles, *Helter Skelter: L.A. Art in the 1990s*. At first the eye is fooled into thinking that it is seeing the remains of a rock concert, but further investigation reveals that the amplifier is just a hollow shell—painted canvas stretched and stapled around wood stretcher bars. This pink muted guitar amp presents a bittersweet moment of loss as a once-powerful object is rendered useless by silence.

Oshiro grew up in a typical middle-class home built for American servicemen in Okinawa. *Kitchen Project* (2005) is another still life, one of the American domestic landscape. Appearing to have been ordered straight out of an Ikea catalogue, rows of generic kitchen cabinets, a sink, and a range hood (minus the range) are presented deadpan, as if in a new suburban house. Is it sculpture, architecture, interior design, or just a commercial product display? Ambiguity and illusion fascinate Oshiro, and they can be achieved only through meticulous, labor-intensive craftsmanship. This is his way of seeing and making sense of the culture around him: to make work that looks exactly like what it is—or isn't—no more, no less.

Kaz Oshiro was born in 1967 in Okinawa, Japan, and moved to the United States in 1986. He received his BA and MFA at California State University, Los Angeles. He has had one-person exhibitions in 2002 and 2004 at Rosamund Felsen Gallery, Los Angeles. In 2004 his work was included in group exhibitions at the Orange County Museum of Art, Newport Beach, California; the Contemporary Arts Center, Cincinnati; and Angstrom Gallery, Dallas.

JAMES ELAINE

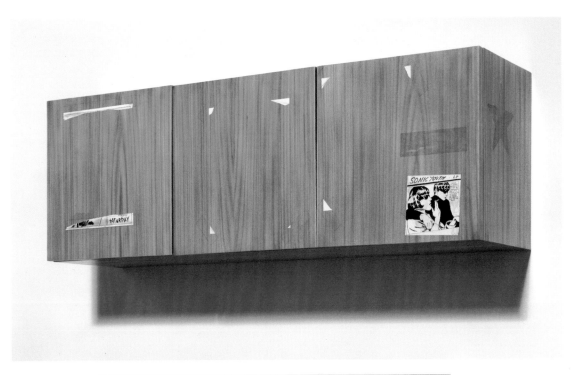

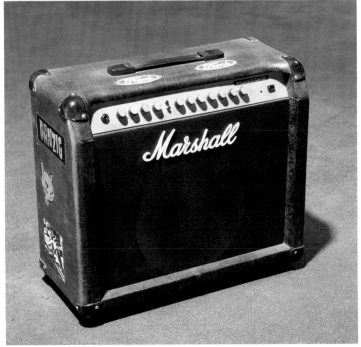

top: Kaz Oshiro
Wall Cabinet #2 (Sonic Youth), 2003–4
Acrylic on stretched canvas
15 1/8 x 45 1/2 x 12 in. (38.4 x 115.6 x 30.5 cm)
Collection of Niels Kantor, Los Angeles

bottom: Kaz Oshiro
Marshall Amp (Freak), 2000
Acrylic and Bondo on stretched canvas
18 1/2 x 21 1/2 x 9 1/2 in. (47 x 54.6 x 24.1 cm)
Collection of Michael and Crystal Paselk, Corona del Mar, California

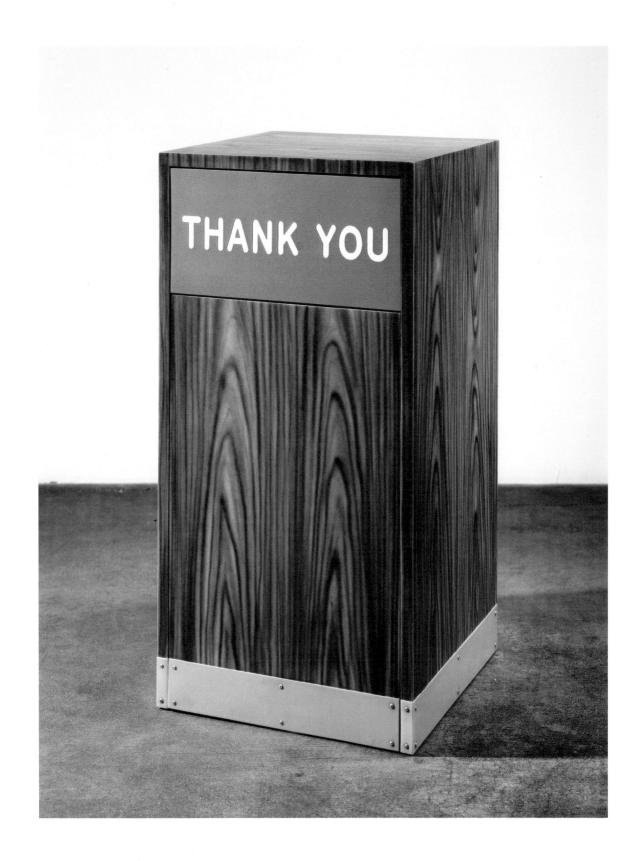

Kaz Oshiro
Trash Bin #3 (woodgrain, with orange), 2003–4
Acrylic and Bondo on stretched canvas
39 1/8 x 20 1/8 x 20 1/8 in. (99.4 x 51.1 x 51.1 cm)
Collection of James Corcoran, Los Angeles

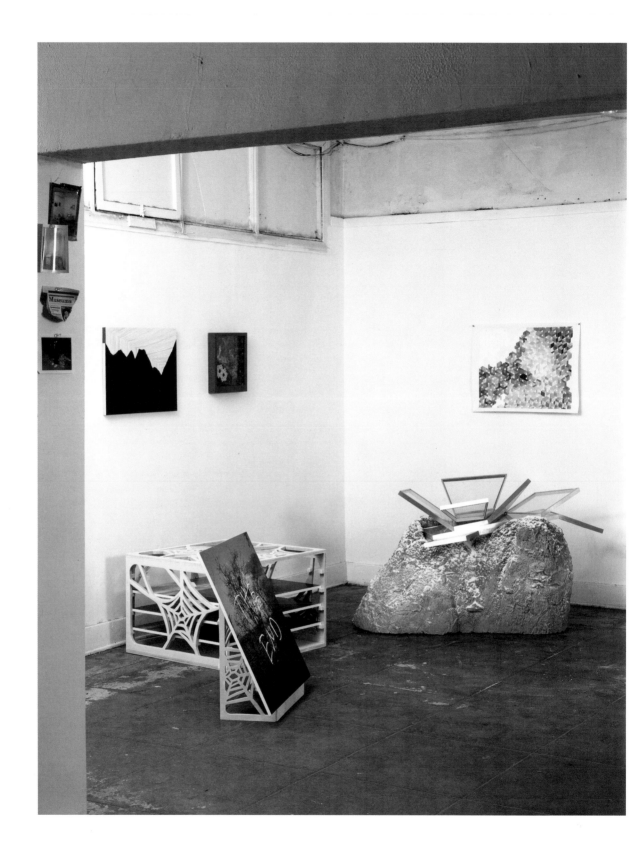

Andy Ouchi's studio, 2004

Andy Ouchi

During a recent conversation about his work, Andy Ouchi, who is also a talented musician, invoked Sam Cooke. Ouchi pointed to how Cooke, unlike many other musicians, was able to reenact, rather than simply illustrate, specific moments or emotional states. For Ouchi, one goal of art is to provoke a multicentered present, a translation of Cooke's reenactments to the visual realm.

A recent piece, *This is what I was talking about* (2004), is based on a staircase at the Hiroshima Museum that bears the imprint of a woman's silhouette, burned into its surface by the atomic blast. Ouchi's sculpture, with its shadow figures (of the artist and his ex-girlfriend) and crystalline plant, is an example of what he refers to as "meaning convulsing" — a cohesion of multiple moments and readings into a singular experience in the present, intimating the sublime. According to Ouchi, "there is something very important about being able to express things in a non-linear way — it seems more like the way we make sense of the world."[1]

Looking at *and sometimes Y (to Bruce Nauman)* (2004), which takes as its jumping-off point Nauman's *Cast of the Space under My Chair* (1965–68), one is able to see, again, how Ouchi opens up reality through his works. In talking about his work, he makes reference to Rosalind Krauss and her reading of surrealist sculpture as "a foreign body intruding itself into the fabric of real space — making a weird island of experience which disrupts a rational sense of causality."[2] In Ouchi's piece there is a sense of this "weird island" as he represents the space under his chair as multiple translucent, crystal-like vectors rather than a solid. When we look at the piece, the space around us begins to assume the structure of his sculpture, opening up the possibility in our reality of a different type of perception.

Notes

1. Andy Ouchi, e-mail correspondence with the author, October 6, 2004.
2. Rosalind Krauss, "A Game Plan: The Terms of Surrealism" (1977), in *Passages in Modern Sculpture* (New York: Viking, 1977), 146.

Andy Ouchi was born in 1974 in Stanford, California, and received his MFA from Art Center College of Design. He currently lives in Los Angeles. Recent exhibitions include *9331/3*, a collaboration with Andy Alexander, at China Art Objects, Los Angeles, and shows at Hayworth Gallery and Low Gallery, also in Los Angeles.

AIMEE CHANG

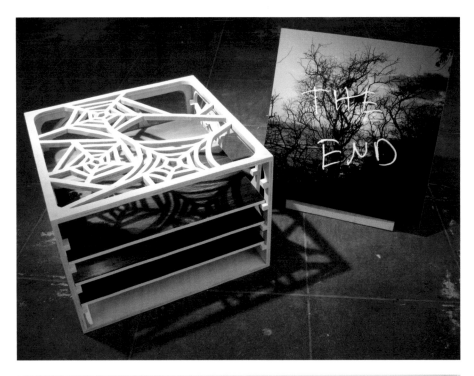

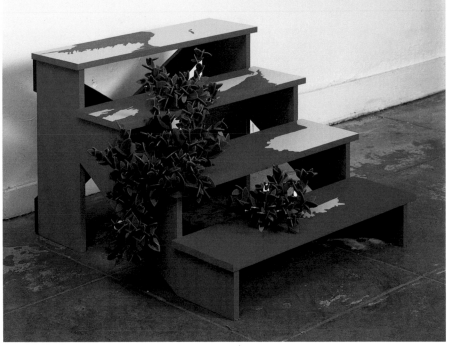

top: Andy Ouchi
Four nights of a dreamer (alternate endings), 2004 (cat. no. 40)

bottom: Andy Ouchi
This is what I was talking about, 2004 (cat. no. 41)

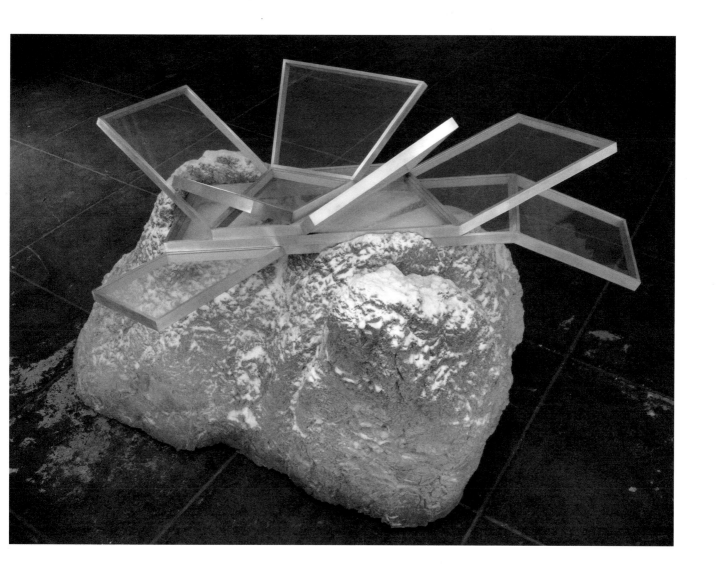

Andy Ouchi
Untitled, 2004 (cat. no. 42)

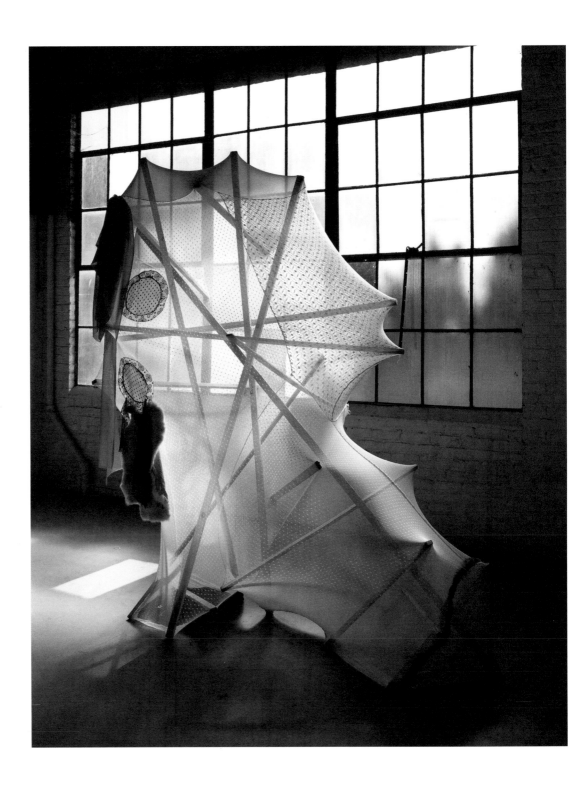

Lara Schnitger
Betty Ford, 2004 (in process, cat. no. 44)

Lara Schnitger

An artist who has given new meaning to the phrase "costume drama," Lara Schnitger maintains a practice involving installation, sculpture, and performance. What most clearly links the three is costume. In her performances, Schnitger's costumes inform unfolding dramas, functioning as freestanding scenery and perhaps "extras" rather than as actual clothing for actors, but when they are presented as sculpture, drama becomes a quality of costume. Her hollow, freestanding forms, made of elaborately stitched-together fabric skins stretched like irrational tents over armatures of joined sticks, exploit the tension and compression that allow them to stand, generating a tense dynamism. Made of fabrics often printed in bold patterns (in recent works, sometimes printed by the artist herself), they are suggestive of figures frozen in the midst of intense movement, clad in wild, at times suggestive and provocative, couture.

The use of fabrics and the suggestion of costume and fashion in sculptural practice are hardly new—if anything, they have become more common of late, with artists taking advantage of opportunities to use costume for associations of character and narrative, and to use fabric and fashion for complex coding. Schnitger is rare, however, in her determination to make works that are simultaneously invested in a reading of codes and an appreciation of form. Though they still seem very much like clothing, Schnitger's self-actualizing costumes make it clear that they have left behind any sense of obligation to bodies that might have donned them (taking to an extreme couture's often adversarial relationship to its wearer) by insisting on their own anatomy, being supported by their own structures, and becoming characters or players unto themselves. For all the signifying reasons we wear and pose in clothing, these getups wear themselves.

Lara Schnitger was born in 1969 in Haarlem, the Netherlands, and studied at the Royal Academy of Art, The Hague; the Academy of Visual Art, Prague; Ateliers '63, Amsterdam; and the Center for Contemporary Art, Kitakyushu, Japan. Her work has been shown in solo exhibitions at the Chinese European Art Center, Xiamen, China; Anton Kern Gallery, New York; and the Project Room at the Santa Monica Museum of Art, Santa Monica, California. She was also represented in the exhibition *Building Structures* at P.S.1 Contemporary Art Center, Long Island City, New York.

CHRISTOPHER MILES

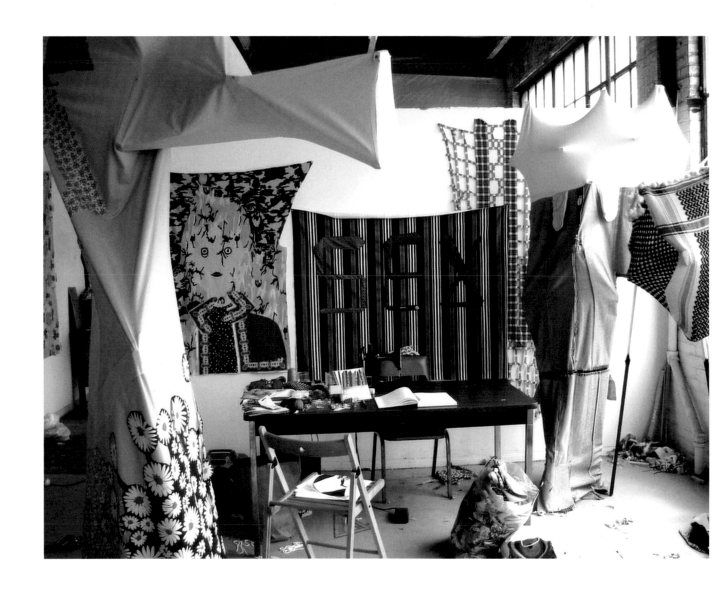

Lara Schnitger's studio, 2002

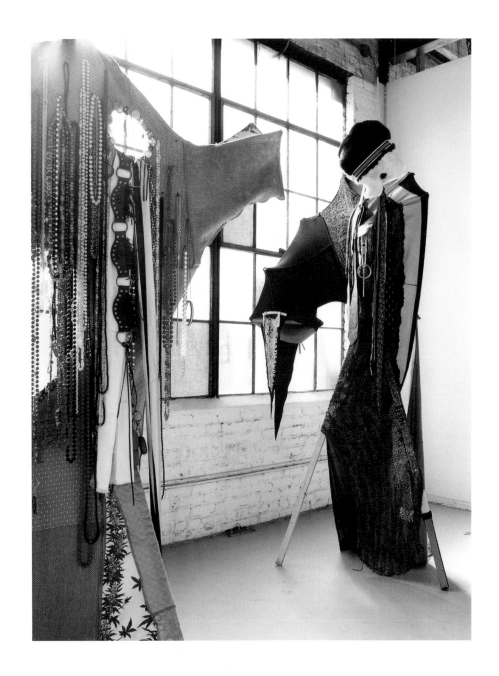

Lara Schnitger's studio, 2004

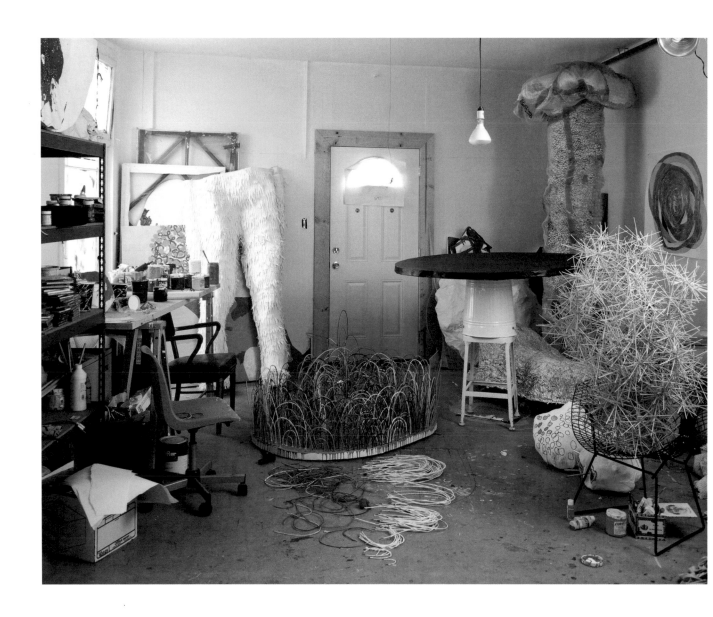

Mindy Shapero's studio, 2004

Mindy Shapero

Mindy Shapero's sculptures are rooted in a fascination with how objects and physical phenomena are sited and transformed within fantasy narrative. Thus, essences yield to imagination in Shapero's works, which are studies of how objects, and occasionally figures, take on childish airs of the fantastic or the uncanny as they do in storybooks, fables, and myth: the magic pebble, the tree that talks, the abominable snowman. Her work is indicative of a generation that is post–high/low in its refusal to split the world into fine art and kitsch, unabashedly promiscuous and assertively cosmopolitan in its use of style and device, and equally enamored and skeptical of spirituality, secularism, and consumerism. While her work is synthesized within stylistic parameters insistent on its relation to drawing and cartooning — particularly in the vein of the animated film *Yellow Submarine* or the pop/psychedelic surrealism of Peter Max — it is as likely to borrow from East as from West and to suggest the baroque drama of Bernini tableaux as the art brut of Jean Dubuffet or the kid-friendly assimilated psychedelia of Sid and Marty Krofft television shows.

Basic to Shapero's practice — and to the practices of many artists who, like her, have attempted to make objects magic or to objectify magic — is the act of mixing attributes. Thus, she creates boulders that sprout scales or feathers, clouds that stand like sheep on legs of lightning, plumes of smoke that morph into bouquets, bursts of radiant energy that solidify into bulbous masses like snowballs or lumps of coal, and rainbows that burn down like unattended cigarettes. Although suggestive of narrative, and born of stories the artist constructs while working in the studio, Shapero's works do not tell stories so much as they act as compelling catalysts for viewers to begin weaving tales of their own.

Mindy Shapero was born in 1974 in Louisville, Kentucky. She completed her BFA at the Maryland Institute College of Art and her MFA at the University of Southern California. Her work has been exhibited at Anna Helwing Gallery, Los Angeles, and in the *2004 California Biennial*, Orange County Museum of Art, Newport Beach, California.

CHRISTOPHER MILES

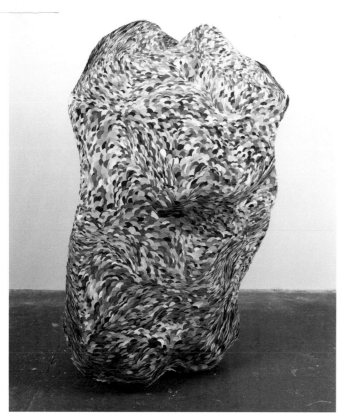

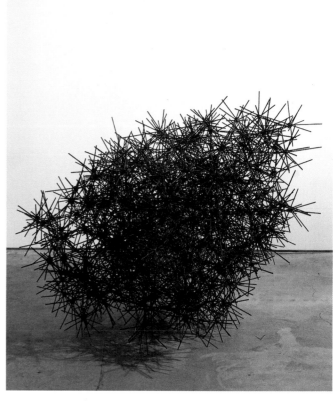

Mindy Shapero
The orb (it exists behind your eyes and you only see it when you die and it tells you everything you always wanted to know, 2004 (cat. no. 51)

Mindy Shapero
Almost the exact feeling one has when staring at the <u>blinded by the light</u> for too long just before anything is about to happen, similar to the images that you see when closing your eyes and pressing into your eyeballs (blackness), 2004 (cat. no. 49)

right: Mindy Shapero, *The smoke bomb (exists behind your eyes and you only see it when you die and then it releases all phylogenetic memories)*, 2003 (cat. no. 47)

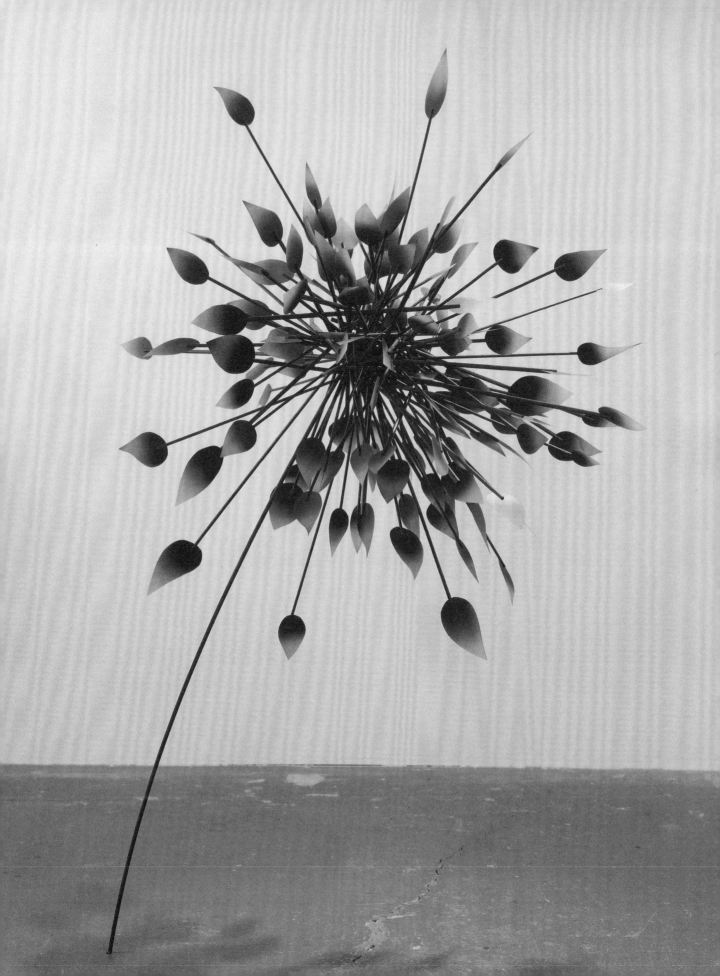

Checklist of the Exhibition

Lauren Bon

1
Wise Elders, 2005
Plexiglas, gelatin silver print, steel
Two pieces, 108 x 36 x 2 1/2 in.
(274.3 x 91.4 x 6.4 cm) each
Courtesy of the artist

Jedediah Caesar

2
1,000,000 A.D., 2005
Mixed media
Dimensions variable
Collection of Craig Robins, Miami Beach,
Florida

Kate Costello

3
Untitled, 2002
Paper, cement, wood
48 x 24 x 50 in. (121.9 x 61 x 127 cm)
Courtesy of the artist

4
Portrait Gallery, 2003–present
Mixed media
Dimensions variable
Courtesy of the artist

Krysten Cunningham

5
Matter Sucks Matter, 2004
Sisal, spray paint, steel, plywood, latex
paint, zebrawood
Height: 58 1/2 in. (148.6 cm); diameter:
53 in. (134.6 cm)
Collection of Shirley Morales and Kevin
McSpadden, Los Angeles

6
Metaphysical Lunchbox, 2004
Sisal, aluminum, spray paint, zip ties
19 1/2 x 19 1/2 x 19 1/2 in. (49.5 x 49.5 x
49.5 cm)
Courtesy of the artist

7
New Sputnik, 2004
Dyed jute, steel
35 x 35 x 35 in. (88.9 x 88.9 x 88.9 cm)
Courtesy of the artist

8
Stella's Eye, 2004
Sisal, zebrawood, spray paint
78 x 78 x 10 in. (198.1 x 198.1 x 25.4 cm)
Courtesy of the artist

9
Infinity Is Fuzzy, 2005
Anodized aluminum, acrylic yarn, zip ties
96 x 24 x 17 in. (243.8 x 61 x 43.2 cm)
(estimate)
Courtesy of the artist

Hannah Greely

10
Doug, 2004
Polyester resin, oil paint, ink, dirt, glue
8 3/4 x 2 3/4 x 2 1/2 in. (22.2 x 7 x 6.4 cm)
Courtesy of Andrea Rosen Gallery,
New York

11
Joe, 2004
Polyester resin, oil paint, ink
3 x 14 x 9 1/2 in. (7.6 x 35.6 x 24.1 cm)
Courtesy of Andrea Rosen Gallery,
New York

12
Molly and Johnny, 2004
Polyester resin, oil paint, ink
8 3/4 x 13 x 13 in. (22.2 x 33 x 33 cm)
Collection of Dean Valentine and
Amy Adelson, Los Angeles

13
Muddle, 2004
Coconut fiber, silicone glue
11 x 43 x 29 in. (27.9 x 109.2 x 73.7 cm)
Courtesy of Black Dragon Society,
Los Angeles, and Andrea Rosen Gallery,
New York

Taft Green

14
*Reaction Facets: International Seaport; Port 1
of 2; energy distribution, holding light*, 2005
Domestic and imported hardwoods, paint,
steel, fabric
54 x 75 x 60 in. (137.2 x 190.5 x 152.4 cm)
Courtesy of the artist and Richard Telles
Fine Art, Los Angeles

Matt Johnson

15
Two Orange Peels, 2003
Cast bronze, oil paint
Dimensions variable
Collection of Matt Aberle, Los Angeles

16
Breadface, 2004
Cast plastic, oil paint
4 x 4 x 3/8 in. (10.2 x 10.2 x 1 cm)
Courtesy of the artist and Taxter and
Spengemann, New York

17
Puzzle Piece, 2004
Bronze, paper, UV varnish
24 x 30 x 5 in. (61 x 76.2 x 12.7 cm)
Collection of Martin and Rebecca
Eisenberg

18
Seaweed Sculpture, 2005
Bronze
16 x 36 x 48 in. (40.6 x 91.4 x 121.9 cm)
Courtesy of the artist and Taxter and
Spengemann, New York

Aragna Ker

19
In the Spaces of Multiplicity, 2004
Wood, foam, spray paint, felt
48 x 60 x 24 in. (121.9 x 152.4 x 61 cm)
Courtesy of the artist

20
Sunburst, 2004
Wood and spray paint
Height: 3/4 in. (1.9 cm); diameter: 96 in.
(243.8 cm)
Courtesy of the artist

Olga Koumoundouros

21
Sagamore: The Good Life, 2005
PVC, wire, Hydrocal, spray foam,
newspaper, vermiculite
88 x 99 x 99 in. (223.5 x 251.5 x 251.5 cm)
(estimate)
Courtesy of the artist and Adamski Gallery
for Contemporary Art, Aachen, Germany

Renee Lotenero

22
The Red One, 2003
Steel, tiles, plastic, resin, photographs
Dimensions variable
Collection of Antonio Puleo, Los Angeles

23
La Piazza Tenera, 2005
Handmade tiles, photographs, grape vines,
Plexiglas, lacquer paint, steel, paper,
found objects
Dimensions variable
Courtesy of the artist

Nathan Mabry

24
Three-Toed Love, 2003
Clay, aluminum, plastic, paint
60 x 30 x 28 in. (152.4 x 76.2 x 71.1 cm)
Collection of Gerald Niederwieser,
Los Angeles

25
THING THANG, 2004
Bone china, steel
42 x 162 x 5 in. (106.7 x 411.5 x 12.7 cm)
Courtesy of the artist and cherrydelosreyes,
Los Angeles

26
A Touching Moment (Tooting My Own Horn),
2005
Terra-cotta, wood, paint
60 x 42 x 30 in. (152.4 x 106.7 x 76.2 cm)
(estimate)
Courtesy of the artist and cherrydelosreyes,
Los Angeles

Rodney McMillian

27
Untitled (Silver Balloon), 2004
Clay, acrylic, glue
14 x 21 x 27 in. (35.6 x 53.3 x 68.6 cm)
Collection of Jeffrey Kerns, Los Angeles

28
Wood Paneling, 2004
Wood paneling
Dimensions variable
Courtesy of the artist and Susanne
Vielmetter Los Angeles Projects

Chuck Moffit

29
eros bruises thanatos, 2005
Cast iron, steel, aluminum, carbon fiber,
foam, lambskin, wood
85 x 92 x 64 in. (215.9 x 233.7 x 162.6 cm)
Collection of the artist

Kristen Morgin

30
Piano Forte, 2004
Unfired clay, wood, wire, salt, cement,
glue
72 1/2 x 46 x 97 in.
(184.2 x 116.8 x 246.4 cm)
Collection of the artist

31
Sweet and Low Down, 2005
Unfired clay, wood, wire, cement, glue
54 x 72 x 204 in.
(137.2 x 182.9 x 518.2 cm) (estimate)
Collection of the artist

Joel Morrison

32
Blue collar bullet for a white collar crime, 2005
Fiberglass, enamel paint over found
objects and Duraflame cans
37 x 53 x 39 in. (94 x 134.6 x 99.1 cm)
Courtesy of Faure & Light Gallery, Santa
Monica

33
Untitled, 2005
Stainless steel
90 x 48 x 36 in. (228.6 x 121.9 x 91.4 cm)
Collection of J. Ben Bourgeois

34
Untitled, 2005
Aluminum, paint, Formica
120 x 36 x 24 in. (304.8 x 91.4 x 61 cm)
The Paul Rusconi Collection, Los Angeles

Michael O'Malley

35
Untitled Configuration 8.04, from the series
The Fantastic Interior, 2004
Plaster, steel
192 x 48 x 24 in. (487.7 x 121.9 x 61 cm)
Courtesy of the artist and cherrydelosreyes,
Los Angeles

36
Untitled Object 7.04, from the series
The Fantastic Interior, 2004
Hollow-core door, wood, steel
43 x 43 x 22 in. (109.2 x 109.2 x 55.9 cm)
Courtesy of the artist and cherrydelosreyes,
Los Angeles

37
Untitled Object 11.04, from the series
The Fantastic Interior, 2004
Hydrocal, steel, polystyrene foam
42 x 60 x 55 in. (106.7 x 152.4 x 139.7 cm)
Courtesy of the artist and cherrydelosreyes,
Los Angeles

Kaz Oshiro

38
Pink Marshall Stack Wall (Three Marshall
Double Stacks), 2002
Acrylic and Bondo on stretched canvas
72 x 90 x 14 1/4 in.
(182.9 x 228.6 x 36.2 cm)
Collection of Peter Norton, Santa Monica

39
Kitchen Project, 2005
Acrylic on stretched canvas
Dimensions variable
Courtesy of the artist and Rosamund
Felsen Gallery, Santa Monica

Andy Ouchi

40
Four nights of a dreamer (alternate endings),
2004
Wood, wood stain, Epson prints mounted
on Gatorboard
20 x 72 x 47 in. (50.8 x 182.9 x 119.4 cm)
Courtesy of the artist

41
This is what I was talking about, 2004
MDF, Plexiglas, oil, acrylic paint
22 x 36 x 36 in. (55.9 x 91.4 x 91.4 cm)
Courtesy of the artist

42
Untitled, 2004
Styrofoam, papier-mâché, sand, Hydrocal,
glass, aluminum, wood, acrylic paint,
plastic
36 x 36 x 60 in. (91.4 x 91.4 x 152.4 cm)
Courtesy of the artist

Lara Schnitger

43
Pedo Pops, 2002
Jeans, T-shirt, wood, pins
95 x 59 x 35 in. (241.3 x 149.9 x 88.9 cm)
Collection of Laura Steinberg and
B. Nadal-Ginard, Chestnut Hill,
Massachusetts

44
Betty Ford, 2004
Lycra, fur, wood, pearls, pins
91 x 86 x 62 in. (231.1 x 218.4 x 157.5 cm)
Courtesy of the artist and Anton Kern
Gallery, New York

45
Tickler-stick, 2004
Wood, fabric, zippers, pins
153 x 36 x 40 in. (388.6 x 91.4 x 101.6 cm)
Courtesy of the artist and Anton Kern
Gallery, New York

46
Lost Hippie, 2004
Fabric, wood, necklaces, scarves, watches,
earrings, pins
85 x 62 x 20 in. (215.9 x 157.5 x 50.8 cm)
Courtesy of the artist and Anton Kern
Gallery, New York

Mindy Shapero

47
The smoke bomb (exists behind your eyes and
you only see it when you die and then it releases
all phylogenetic memories), 2003
Wood, acrylic, Duralar
78 x 48 x 60 in. (198.1 x 121.9 x 152.4 cm)
Courtesy of the artist and Anna Helwing
Gallery, Los Angeles

48
I know you can't see through the air in this
place, especially with the lights so low, 2003–4
Foam, Celluclay, paper, wood, acrylic
38 x 41 x 33 in. (96.5 x 104.1 x 83.8 cm)
Collection of Merry Norris, Los Angeles

49
Almost the exact feeling one has when staring at
the blinded by the light for too long just before
anything is about to happen, similar to the
images that you see when closing your eyes and
pressing into your eyeballs (blackness), 2004
Wood, acrylic
36 x 40 x 38 in. (91.4 x 101.6 x 96.5 cm)
(approx.)
Collection of Paul Rickert; courtesy of
Anna Helwing Gallery, Los Angeles

50
The orb (it exists behind your eyes and you only
see it when you die and it tells you everything
you always wanted to know), 2004
Coloraid, paper
37 x 26 x 25 in. (94 x 66 x 63.5 cm)
Courtesy of the artist and Anna Helwing
Gallery, Los Angeles

51
Almost the exact feeling one has when staring at
the blinded by the light for too long just after
everything begins to happen, similar to the
images that you see when you open your eyes
after closing your eyes and pressing into your
eyeballs (whiteness), 2004–5
Wood, acrylic
36 x 40 x 38 in. (91.4 x 101.6 x 96.5 cm)
(approx.)
Collection of Paul Rickert; courtesy of
Anna Helwing Gallery, Los Angeles

Fellows of Contemporary Art Membership (as of November 2004)

Nick Agid
Dewey E. Anderson
Barbara and Charles Arledge
Leisa and David Austin
Shirley Martin Bacher
Beatrix and Gardy Barker
Irene and Jerry Barr
Ann and Olin Barrett
Kay Sprinkel and Geoffrey C. Beaumont
Nancy Berman and Alan Bloch
Lanie and Lazare Bernhard
Jo and Charles Berryman
Ellie Blankfort and Peter Clothier
Suzanne and David Booth
Carol and Ken Brown
Sheridan Brown
Gay and Ernest Bryant
Bente and Gerald E. Buck
JoAnn and Ron Busuttil
Susan and John Caldwell
Susan B. Campoy
Maureen and Robert Carlson
Mary and Gus Chabre
Britt and Don Chadwick
Charlotte Chamberlain
 and Paul Wieselmann
Sara Muller and Dennis Chernoff
Kitty Chester
Angel and Stephen Cohen
Barbara Cohn
Francine and Herb Cooper
Diane and Michael Cornwell
Zoe and Don Cosgrove
Beryl Cowley
Louise Danelian
Kimberly Davis
Marina Forstmann Day
Hem-Young and Dominic de Fazio
Laura Donnelley-Morton
 and John Morton
Julie Du Brow and Mark A. Johnson
Sandra and Victor Ell
Lulu Epstein
Suzanne Felsen and Kevin Swanson
Joanne and Beau France
Merrill R. Francis
Elaine Freund
Judy and Kent Frewing
Jacquie and Stuart Friedland
Lisa and Jerry Friedman
Marilyn Gantman and Betty Cooperman
Imara and Seth Geller
Eve and Peter Gelles
Linda Genereux and Timur Galen
Sirje and Michael Gold

Homeira and Arnold Goldstein
Linda and Arthur Goolsbee
Donna Gottlieb
Vikie and Ted Hariton
Mary Elizabeth and Al Hausrath
Portia Hein and Philip Martin
Carol and Warner Henry
Samuel Hoi
Niki Horwitch and Stephen Berg
Roberta Baily Huntley
Sally and Bill Hurt
Diane and David Jacobs
Linda and Jerry Janger
Francie Jones and Adam Weissburg
Gloria and Sonny Kamm
Stephen A. Kanter
Tobe and Greg Karns
Nancy and Bernie Kattler
Margery and Maurice Katz
Suzanne and Ric Kayne
Jeremy Kidd
Brian Kite and Kate O'Neal
Barbara and Victor Klein
Phyllis and John Kleinberg
Sherry and Michael Kramer
Smrithi and Basker Krishnan
Hannah and Russel Kully
Laurie N. La Shelle
 and Robert Kerslake
Larry Layne and Sheelagh Boyd
Joyce and Tom Leddy
Catie Lee and Kyle Casazza
Dawn Hoffman Lee and Harlan Lee
Lydia and Chuck Levy
Peggy and Bernard Lewak
Penny and Jay Lusche
Linda P. Maggard
Ann and Thomas Martin
David Mather and Pam Blacher
Barbara Maxwell
Dee Die and Ted McCarthy
Amanda and James McIntyre
Carolyn and Charles D. Miller
Donna and Clinton W. Mills
Cindy Miscikowski and Doug Ring
Joy and Jerry Monkarsh
Hilarie and Mark Moore
Kay Mortenson and R. Kelly
Garna and Steven Muller
Ann and Bob Myers
Lois and Richard Neiter
Sandra Kline Nichols
Mary and Jon Nord
Peter Norton
Sarah and Bill Odenkirk

Cathie and David Partridge
Monica Partridge
Jeanne Patterson
Joan Payden
Marisa and Jacques Perret
RL and David A. Peters
Tina Petra and Ken Wong
Peggy Phelps and Nelson Leonard
Bruce Picano and Joseph Morsman
Reese Polesky
Debra and Larry Poteet
Dallas Price-Van Breda
 and Bob Van Breda
Michael Rabkin and Chip Tom
Lonette and Stan S. Rappoport
Kathy Reges and Leonard Pate
Joan B. Rehnborg
Felice and Herbert Reston
David Richards and Geoffrey Tuck
Ellie Riley
Paula A. Rogers and Mitchell Poole
Whitney Rosenson
Barbara and Armin Sadoff
Helene and Robert Schacter
Kathleen Schaefer
Judy and Carl Schlosberg
Esther and Richard Schuster
Jennifer and Anton Segerstrom
Adrienne and Carl Short
Phyllis Siegel
Marjorie and David Sievers
Pam and George Smith
Penny and Ted Sonnenschein
Laurie Smits Staude
Ginny and Richard L. Stever
Joan Tamkin
Laney and Thomas Techentin
Jocelyn Tetel
Elinor and Rubin Turner
Donna Vaccarino
Carolyn and Bob Volk
Julie and Scott Ward
Kathy Watt
Bob Weekley
Linda and Tod White
Mili Julia Wild
Jene M. Witte
Dianna Wong
Laura-Lee and Robert Woods
Sandee Young

Exhibitions Initiated and Sponsored by the Fellows of Contemporary Art

The concept of the Fellows of Contemporary Art, as developed by its founding members in 1975, is unique. Membership dues are used to organize and sponsor exhibitions for emerging and midcareer California artists; to publish outstanding professional catalogs and other documents; to encourage a broad range of exhibition sites; and to provide stimulating educational experiences for the members. The intention is to collaborate with the art community at large and to nurture the expression of creative freedom.

1976
Ed Moses Drawings, 1958–1976
Frederick S. Wight Art Gallery, University of California, Los Angeles

1977
Unstretched Surfaces/ Surfaces Libres
Los Angeles Institute of Contemporary Art

1978
Wallace Berman Retrospective
Otis Gallery, Otis College of Art and Design, Los Angeles

1979
Vija Celmins: A Survey Exhibition
Newport Harbor Art Museum, Newport Beach

1980
Variations: Five Los Angeles Painters
University Art Galleries, University of Southern California, Los Angeles

1981
Craig Kauffman: Comprehensive Survey, 1957–1980
La Jolla Museum of Contemporary Art

Paul Wonner: Abstract Realist
San Francisco Museum of Modern Art

1982
Changing Trends: Content and Style—Twelve Southern California Painters
Laguna Beach Museum of Art

1983
Variations II: Seven Los Angeles Painters
Gallery at the Plaza, Security Pacific National Bank, Los Angeles

1984
Martha Alf Retrospective
Los Angeles Municipal Art Gallery

1985
Sunshine and Shadow: Recent Painting in Southern California
Fisher Gallery, University of Southern California, Los Angeles

James Turrell
The Museum of Contemporary Art, Los Angeles

1986
William Brice
The Museum of Contemporary Art, Los Angeles

1987
Variations III: Emerging Artists in Southern California
Los Angeles Contemporary Exhibitions

Perpetual Motion
Santa Barbara Museum of Art

1988
Jud Fine
La Jolla Museum of Contemporary Art

1989
The Pasadena Armory Show 1989
The Armory Center for the Arts, Pasadena

1990
Lita Albuquerque: Reflections
Santa Monica Museum of Art

1991
Facing the Finish: Some Recent California Art
San Francisco Museum of Modern Art

Roland Reiss: A Seventeen-Year Survey
Los Angeles County Municipal Art Gallery

1992
Proof: Los Angeles Art and the Photograph, 1960–1980
Laguna Art Museum, Laguna Beach

1993–94
Kim Abeles: Encyclopedia Persona, a Fifteen-Year Survey
Santa Monica Museum of Art

1994
Plane/Structure
Otis Gallery, Otis College of Art and Design, Los Angeles

1995
Llyn Foulkes: Between a Rock and a Hard Place
Laguna Art Museum, Laguna Beach

1997
Scene of the Crime
UCLA at the Armand Hammer Museum of Art and Cultural Center, Los Angeles

1998
Access All Areas
Japanese American Cultural and Community Center, Los Angeles

1999
Bruce and Norman Yonemoto: Memory, Matter, and Modern Romance
Japanese American National Museum, Los Angeles

Eleanor Antin
Los Angeles County Museum of Art

2000
Flight Patterns
The Museum of Contemporary Art at the Geffen Contemporary, Los Angeles

2002
Michael Brewster: See Hear Now—a Sonic Drawing and Five Acoustic Sculptures
Los Angeles Contemporary Exhibitions

On Wanting to Grow Horns: The Little Theater of Tom Knechtel
Ben Maltz Gallery, Otis College of Art and Design, Los Angeles

2003
Whiteness, a Wayward Construction
Laguna Art Museum, Laguna Beach

George Stone: Probabilities—a Midcareer Survey
Barnsdall Municipal Art Gallery, Los Angeles

2004
Topographies
San Francisco Art Institute